禪武太極刀

作者 李嬋玲

掃碼欣賞禪武太極刀

翻譯 李嬋玲

祝賀　徒李嬋玲著作《禪武太極刀》新書出版！

弘揚國粹　發揚武德

陳家溝陳氏第十九世嫡宗傳人　陳瑜致賀

祝賀　徒李嬋玲著作《禪武太極刀》新書出版！

奮發圖強
自強不息

山東正和太極拳館
陳氏太極拳第十二代傳人　尹正華致賀

祝賀　徒李嬋玲著作《禪武太極刀》新書出版！

道法自然

師程克錦致賀

祝賀　李嬋玲師姐禪武太極刀新書出版

師兄董繩周敬賀

德藝雙馨 弘揚國粹

太極感悟

河洛大化孕無極。無生有，極生二，三才四靈，五行八卦平。剛柔並濟修內外　健體魄，盡天性。

結緣太極數十載。既練攻，又學防。掩手肱拳，拳致片敵傷。中華武術千萬種，唯太極，不用商。

禪武太極刀

作者簡介

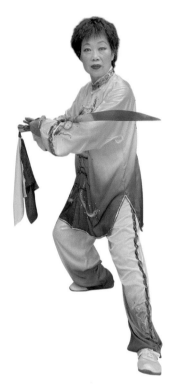

李嬋玲

2020 年獲頒授中華百傑

2020 中國少林武術段位七段

中國武術段位六段

國際武術段位六段

香港紅館太極康樂會主席

香港南北國術總會副會長

比賽獲獎項目

2020 年沙田錦賽器械刀亞軍

2019 年 12 月《日本德島國際武術交流大會》陳式太極刀 和 陳式太極拳 56 式競賽套路一等賞

2019 年 7 月澳博杯《第八屆澳門國際武道大賽》太極刀術第一名，陳式太極拳 56 式第二名

2019 年 7 月《首屆世界武術錦標賽》第三套新標准陳式太極拳亞軍，自選刀術季軍

2019 年〈《紫荊花国際武術公開賽》第三套新標淮陳式拳、陳式劍和自選太極刀一等獎

2019 年 4 月《日本第二回東京國際傳統武術文化節》器械金賞

2019 年《沙田武術錦標賽》陳式 56 拳第二名，自選太極刀第三名

2018 年全港公開太極錦標賽陳式太極拳規定套路銀獎

2018 年《日本第一回東京國際傳統武術文化節》陳式太極拳 56 式、大極單刀第四名

2018 年 10 月《深水埗區慶祝國慶暨傳統功夫》精英組第三套新標準陳式太極拳、陳式劍金獎，太極刀銀獎

2018《首屆世界太極拳交流大會》陳式拳和自選太極刀一等獎

2018 年《首屆香港太極、養生、武術精英公開賽》女子全能金獎，陳式競賽套路 56 式太極拳和 42 式太極劍冠軍，42 式太極拳亞軍

2018 年《第 13 屆香港國際武術比賽》國家競塞套路 42 式太極劍、 42 式太極拳、自選太極刀第一名

2017 廣東中山《第五屆東亞武術交流大會》陳式太極拳 56 式、陳式劍和陳式刀第一名

2017 年《第 12 屆香港國際武術比賽》傳統刀術、第三套新標準太極拳、太極劍第一名

2017 年首屆《粤港澳大灣區武術聯盟金紫荆花大觀摩大賽》第三套新標準陳式太極拳、太極劍和自選刀金獎

2017 年《慶祝國慶傳統功夫》太極拳精英組陳式太極刀和陳式太極拳56 式銅獎

2017 年全港公開太極錦標賽金獎

2016 北京《第七屆華夏武狀元國際爭霸賽》太極刀和競賽套路陳式 56 拳第一名

2016 年香港《沙田武術錦標賽》太極器械組（刀）第一名

2015 年香港《沙田武術錦標賽》太極器械組太極刀第二名

2015 年中信國安杯第五屆中國《四川國際峨眉武術節》太極拳一等獎,自選太極刀二等獎

2014 年《第九屆香港國際武術比賽》陳式太極競賽套路 56 式和陳式太極五段位套路第一名

2014 年《第 22 屆全港公開內家拳錦標賽》太極器械（刀）季軍

Chanwu Taiji Broadsword 56 forms

Author Sandy Li
Author's Resumes

2020 Award of Outstanding Wushu Master
2020 Chinese Shaolin Wushu Dan 7 Certificate
Chinese Wushu Duanwei grade 6 Certificate
International Wushu Duanwei grade 6 Certificate
Chairwoman of Hong Kong Taiji Recreation Club
Vice Chairwoman of Hong Kong Southern & Northern Martial Art Federation

Awards of Taiji Competition
2020 Shatin Wushu Tournament, Weapon Broadsword Runner-up

2019 Japan Tokushima International Wushu Friendly Match
Taiji Broadsword and 56 Chen Style Taijiquan First Place

2019 SJM Cup the 8th Macau International Wushu Festival, Taiji Broadsword
First Place and second place of 56 Chen Style Taijiquan

2019 F.W. Wushu Championships, New Chen Style Taijiquan Runner Up,
Optional Broadsword 3rd place

2019 Bauhinia International Open Wushu Competition, Chen Style Taijiquan
1st Place, Chen Style Taiji Sword 1st Place, Optional Taiji Broadsword 1st
Place

2019 The 2nd Tokyo International Wushu Culture Festival in Japan, Weapon
Golden Award

2019 Shatin Wushu Tournament, Chen Style 56 Taijiquan 2nd Place
Optional Broadsword 3rd Place

2018 Hong Kong Open Taiji Tournament, New Chen Style Taiji Quan Compulsory Routine Silver Award

2018 Japan The First Tokyo International Wushu Culture Festival, Chen Style 56 Taiji Quan 4thPlace, Taiji Broadsword 4th Place

2018 Sham Shui Po District Celebration of National Day Traditional Kung Fu and Taiji Tournament (Elite Group), Chen Style Taiji Quan and Taiji Sword Golden Award, Taiji Broadsword Silver Award

2018 The First World Taijiquan Exchange Conference, Chen Style Taijiquan and Taiji Broadsword 1st Place

2018 The First Hong Kong Taiji, Health, Wushu (Elite Open) Women's All -Around Gold Award, Chen Style Taijiquan 56 Forms and 42 forms Taiji Sword Champion, 42 Forms Taijiquan Runner Up

2018 The 13th Hong Kong International Wushu Competition, 42 Forms Taijiquan 1st place, 42 Taiji Sword 1st Place, Optional Taiji Broadsword 1st Place

2017 The 5th East Asia Wushu Exchange Conference in Guangdong, Chen Style 56 Taijiquan, Chen Style Taiji Sword and Optional Broadsword all 1st Place

2017 The 12th Hong Kong International Wushu Competition, Chen Style Taiji Broadsword, Chen Style Taijiquan, Chen Style Taiji Sword all 1st Place

2017 The 1st Guangdong Hong Kong Macau Bay Area Wushu Alliance Association, New Chen Style Taijiquan, Chen Style Taiji Sword and Optional Taiji Broadsword all 1st Place

2017 Celebration of National Day Traditional Kung Fu and Taiji Tournament

(Elite Group), Chen Style Taijiquan 56 forms and Chen Style Taiji Sword Silver Award,

2017 Hong Kong Open Taiji Tournament, Taijiquan Golden Award

2016 Beijing 7th Huaxia Wushu Number One Scholar International Competition, Chen Style 56 Forms Taijiquan and Taiji Broadsword both 1st Place

2016 Hong Kong Shatin Wushu Tournament, Weapon Taiji Broadsword 1st Place

2015 Hong Kong Shatin Wushu Tournament, Weapon Taiji Broadsword 2nd Place

2015 The 5th CITIC Guoan Cup 2015 China Sichuan International Emei Wushu Festival, Chen Style Taijiquan 56 Forms 1st Place Taiji Broadsword 2nd Place

2014 The 9th Hong Kong International Wushu Competition, Chen Style Taijiquan and 5 Duan Wei Taijiquan both 1st Place

2014 The 22nd Hong Kong Open Tournament (HKCMADLDA) Weapon Taiji Broadsword 3rd Place

自 序

刀在古代是一種傳統的短兵器，常常使用於戰場拼殺格斗，所以刀的演練風格更接近實戰，格、架、掃、進的刀法神出鬼沒，砍、撩、扎威猛異常，因此才有刀如猛虎，劍似飛鳳之說。三國演義的關羽，身上配上大刀，更有氣勢，給人感覺是很勇武，加上他的正氣和正義，更令人敬佩，很多酒樓、武館和警察局，都設有關公攜刀像的神台，可見刀自古至今給人感覺是多麼崇尚啊！

現代中國的武術教授中，刀己被視為一種不可或缺的部分，刀術被視為一項才藝和正當自衛的技能，而近代刀漸漸成為一種廣泛的全民運動趨勢，不同流派都有各自的刀術，風格特點也都隨著拳種不同而有異，但基本技法還是比較一致的。刀尖用法主要有扎，挑、崩、點、划等，刀刃主要用於劈、砍、剁、斬、截、掃、撩和抹。刀背設計鈍厚，可以用來纏頭裹腦，常聽老師說單刀看手，雙刀看肘，所以單刀練習時，要強調刀和手的相互配合，刀和身的相互的配合，從而達到刀身合一的境界。 練習太極刀的枝法和動作也要保持連綿不斷，勁力到位，剛柔並濟，刀、手、身都要協調配合。

我和大部份太極拳愛好者一樣，特別喜歡運動，尤其是退休後更為自己定造下半生的生活方式，每天練習《武術基本功》，瑜珈、跳舞、太極運動和打坐，其實無論選擇哪一種運動，目的只有三個，1，尋找令

身體更健康，2，身形更健美，3，身心更愉快。我喜歡在各種運中感受其健身效果，感受它給我帶來的舒適度和精神上的愉悅感，最終發現各種運動都有其健身價值。我曾經學習過三年少林拳、刀、棍、也習練過十多年的太極拳，最初因太沉迷武術和太極，越學越想多學，太極拳也學了十幾套，總之以＂博學＂為榮，以＂多學套路＂為樂，當時並沒好好感受和體會每套拳的真締，每天忙個不了，八小時練習也練不完，而最令我著迷是刀術，曾經習練過少林單刀、梅花刀、陳式太極刀、楊式十三刀、混元刀和馬春喜老師的 36 刀，因為我對刀特別有興趣，所以希望和大家分享太極刀的特點，希望大家多點了解太極刀。 我想大部份拳友都學過太極拳和劍，但不一定每個拳友都學過刀術或太極刀，其實所有刀術招式都離不開 1，劈 2，斬，3 抹，4，帶，5，撩 6，扎，7，推 8，截，9，纏 10，裹 11，分，12，剪，13 攔等。練劍比練拳難，練習刀術比練劍更難，刀要求難度更高，所以一般是把拳練好，在基本功夫穩定後再學刀會更容易掌握。

練習太極刀的體會是刀的動作大開大合，刀的招式美觀大方，速度可快如閃電，也可慢如魚兒游水，可鬆可緊，力度可強可柔，節奏鮮明，剛柔並濟，一刀在手，好像世界都掌握在自己手中，令人很有自信，表演時可憑個人心情舒發情感，所以觀眾覺得有觀賞力，因為它能體現出表演者的心里素質，刀的內涵可把個人內心想法明顯地表現出來，所以

觀眾和表演者會有共鳴，除此之外，刀發出響亮的聲音更令自己和觀眾興奮，這是刀獨突的優點。

練習太極刀的好處是通過刀的練習，感受刀的文化，培養勇武、正義、正氣感，尋找刀給我們帶來的愉悅感，刀的招式和技巧，可提升我們上肢和下肢的力量，令下盤更穩固，更可以令身體更靈活，體質更強健，雙腿更有力，刀的招式都非常有氣勢，刀花舞起來令人眼花撩亂，刀彩原是用來迷惑敵人，現在是作為裝飾和增加刀的美感，令觀眾感覺舞刀花非常美觀精彩，除此之外，刀術要求難度高，它最能體現出武術者的風彩，當動作達到要求時，心里會十分興奮，它增加個人自信，雖然刀的發力點和刀花都需要時間練習。但功夫不負有心人，我相信只要堅持刻苦練習，沒什麼做不到。

感恩所有教我刀術的老師們，他們豐富了我的人生，令我活得更精彩，更快樂，身體更健康。刀給人感覺是正氣凜然，豪爽大方，刀的魅力真是無法擋，正如余功保老師說過，刀給人感覺是爽，很爽，十分爽。現把我平時演練的一套太極刀動作和招式和大家一起分享，如示範解釋有錯，請大家多多包涵，也歡迎大家多多指教。

祝大家

身體健康！萬事如意！

李嬋玲

前　言

　　2019 年至今發生冠狀病毒肺炎，在很多國家疫情依然持續，慶幸中國疫情得到控制，記得 2020 年一月份疫情爆發時，當時熱愛運動的鍾南山醫生便鼓勵人民在家打太極，他的一句太極拳好，影響了各省各地發起在家練太極的視頻比賽。其實他早在 2018 年 12 月 21 日已發佈了最新慢阻肺臨牀研究成果，研究發現打太極拳對上述患病者有明顯的成效，他說打太極拳可調整呼吸，鍛鍊下肢，令下盤更穩定，老人不易跌倒，身體更健康，而且可使《慢阻肺》康復。由於冠狀病毒患者正正是會呼吸困難，因此，為了讓我認識的親友們能保持身體健康，我向家人兒子媳婦孫女及朋友推薦打太極拳，很高興我小姑和姑丈也成為太極愛好者，我和她們聊天時間多了，因為太極是大家的共同話題，小姑學習太極後，樣子越來越年輕，精神飽滿，笑容可愛。太極不愧是中國國粹，2020 年 12 月 18 日中國太極拳成功晉列世界非物質文化遺產，證明太極拳對對身心健康有很大影響，希望更多人了解太極運動對身體的改變，它可以提升人體的血清素，減少和治療患上抑鬱症，令日子過得更有意義和更快活，身體更健康更靈活，家庭更幸福，生活更精彩，人生更有希望。由於太極功夫博大精深，永遠學不完，永遠有進步空間，所以永遠有交流，除此之外，無論男女老少都可以學，在家在外都可以練，地方小可以原地站樁、原地起跳、原地撲步、原地單鞭或原地沖拳等。我小孫女洛菲

也很喜歡武術，疫情停課期間，我叫她每天練習武術基本功，因為所有武術套路都是基本功的組合，她很喜歡又學得快，而且又不覺得呆在家悶，她每天做完學校網上功課就玩一會兒拉筋，有時側翻有時倒立，有時踢腿，真的玩得很開心，有見及此，我決定在書裡介紹大家打太極的好處，原因是我和很多拳友都是武術和太極健康的受益人。

除了鍾南山醫生的證明和宣傳，早幾年習主席也提出武術進校園，原因這些學童將會是社會接班人，是社會棟樑，國家富強靠他們，身體健康要靠他們自己鍛練，所以從小就必須鍛練好身體，太極拳運動不太劇烈，也可修心，做父母也可放心讓小朋友參與這活動。記得小時候媽媽常說沒有健康，何來有快樂有希望。

本人自小熱愛武術，也因五叔是京劇編導，所以我從小在戲班後台穿來穿去，目的想看演員練功夫，尤其是騰空起跳動作，覺得好玩又刺激。

退休後的我並非真的退休，因為我對武術之痴迷日益增加，每天至小六小時練習，早午晚都上課，對太極拳，刀、劍、扇都十分喜愛，也曾習練過混元刀和梅花刀，不過我最喜歡練習少林單刀和太極刀，刀對學武者的要求比學拳更高，需下盤更穩，懂用腰胯發勁，還需用意也用力，這和練拳用意不用力相反，這是刀的特有文化和韻味，除此之外，太極刀剛柔並重，威猛無比，動作舒展大方，逢上必下，逢左必右，逢前必收，動作連綿不斷如划艇，刀的發力比拳的發力更明顯而且響亮，所以

更有觀賞力，也更易吸引觀眾的注意，動作可隨自己情感自由發揮，這些都是我特別喜歡練習武術刀和太極刀的原因，現把我平時經常練習的太極刀向大家介紹，這套刀主要是參照馬春喜老師的 36 刀和馮志強老師的混元刀，加上了武刀花和難度高一點的動作，其實什麼叫套路，套路就是把基本功夫練好再把它們組合起來，可以按照傳統，也可以參考別人套路，功夫練到一定的程度，就可以按照自己的能力，架子可高可低，難度可加可減，可以自由選配，最主要是自己喜歡，只要打得順打得爽，越打越健康就好，太極給我的感悟是道法自然，功夫讓我更了解自己，更明白生活，更注重人與人之間的和諧和一切以和為貴，功夫給我精神上莫大鼓勵，去做我從小一直想做的事，所以寫了這一本書，希望大家喜歡。

由於本人學武時年紀較大，表演動作未必完善，懇請前輩們和讀者們多多包涵，給予指導斧正。

李嬋玲

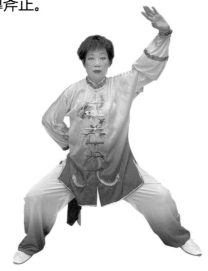

刀的特點和重點要求

1，重心虛實要分明，保持虛靈頂頸，立身中正，眼睛平視，吸氣眼睛回收，呼氣眼睛放遠。

2，刀的動作要連綿不斷，舒展大方，每招每式要到位，眼睛要求目隨刀動，視線最後要集中在一點。

3，刀法和力點都有規範，要求手型，手法、步型、步法，身型、身法都必須清晰和力點位置正確，發力時要勇猛快速，剛勁有力，刀手配合。

4，力點要求：

力從腳跟、腰、肩、手，劈刀靠大臂，刺刀要力達刀尖，平刀出去要旋轉，劈刀要力達刀刃，挑刀要扣腕，刺刀時手腕先內旋再扎刀。

5，刀要貼身，立圓掄臂手臂要貼耳邊，刀處處走立圓。

6，刀 花主要靠身形腰和手腕配合，手腕要放鬆，練習刀花只用拇指和食指扣著，其他三指放鬆。

7，腕關節要靈活，多練手腕基本功，翻腕，扣腕，外翻，內翻，立圓旋轉，增強手腕的靈活性。

8，多練基本功，弓步，馬步，撲步，里合腿，外擺腿，二起腳，後踢腿，提升上下肢的力量和速度。

9，節奏有規矩，是腳、腰、手要順序。

10，重心轉換，有時先扣腳再外翻，有時先外翻再內扣。

11，劍是拳的提升，步入攻防，刀是劍的提升，所以練刀先要練好太極拳的基本功。

12，纏頭動作，纏繞動作從左到右，兩手交叉上提，刀背貼肩背，刀尖下垂，刀從左肩背繞過右肩。

13，裹腦，纏繞動作，從右到左，右手持刀上提，先屈肘再翻腕外旋，刀背緊貼肩背，刀尖下垂，從右肩背繞過到左肩。

14，左手無論外撐或附於胸前都要有膨勁，因為只有兩手互相配合外形才有氣勢，力量才會更大。

15，動作和呼吸也要配合，刀上提是吸，刀下落是呼，刀手隨腰旋轉要協調。

16，掃刀身體蹲底，要求掃刀平地面旋轉，力量達到刀刃。

學太極刀真的是一件非常愉悅和享受的運動，因為太極刀是一門高級的藝術表現，它能表達心中情感，它不單有健身價值，而且動作美觀，不過學太極刀需要札實的基本功，加上勤練，有恆心，能堅持，才能發揮刀的魅力，如果只是以健身為目的，要求也不用太嚴格，但能努力做到要求會有更大收獲。其實每個人都有功夫，只是展示出來不一樣，只要堅持，多看不同刀的刀術和套路，加上多悟，一定會有進步和收穫，其實功夫博大精深，學無止境，所以永遠都有進步空間，我也是要不停學習，不斷提升自己，希望大家練習太極刀後身體更健康，行動更靈活，下肢更強壯，更有自信，更愛運動。

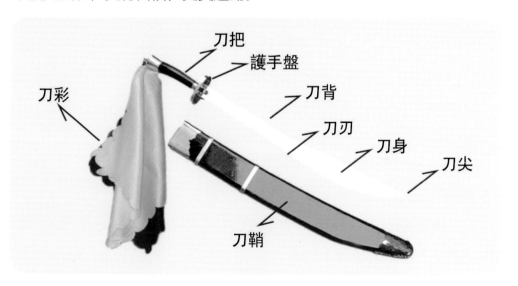

刀把
護手盤
刀彩
刀背
刀刃
刀身
刀尖
刀鞘

太極可以治病

　　我熱愛太極，因為太極改變了我的人生，包括身體健康、快樂、自信、令我對生命充滿熱愛和追求。我三十歲開始患上哮喘，後來因練習太極拳哮喘改善了，腰椎黏連消失了，頸椎問題消失了，想起二十多年前經常去做銀針針灸的痛楚，真是痛得難以忍受，哮喘發作簡直想安樂死，腰椎常常隱隱作痛，十分難受，令我的笑容越來越少，後來又患上甲狀腺，感覺人生活著並非享受快樂，結婚，生兒女，教育他們，身體健康的透支，未退休己身體毛病多多，想起將來孩子長大成家立室，年老不可寂寞渡日，幸好找到自己的興趣，愛上武術和太極，認識不同門派的師傅，可以經常看到他們表演，自己也常常參加各種比賽，走上太極人生的道路，感覺人生如戲，戲如人生，學武術和打太極真的很開心。

　　運動給我帶來意想不到的收穫，當年醫生說我腰痛是退化，不可治，我不相信，堅持每天做熱身運動，正踢腿，外擺腿，里合腿，拉筋，初時因有腰痛和頸部不適，怕再弄傷不敢做，後來踢腿運動後並沒任何不適，於是越踢越起勁，就這樣再也沒有找針灸師，我相信基本功動作有幫助，于是每天在家做，腰患也漸漸消失，所以當時西醫說腰椎老化沒法治是錯的，因為武術基本功的動作令我腰痛消失，而且省時間也省醫療費用，這是我愛上武術的最大原因。

　　我有一位朋友，五十多歲腰腿都有嚴重毛病，遍尋名醫都沒辦法，最後醫生告訴她除了多做手術可能要坐輪椅，這朋友不想從此要與輪椅為伴，於是去学武術練體能，又學太極，結果她腿力增強了，心態也改變了，

走路輕鬆了，她現在七十多歲走路比中年人還快，外擺腿、里合腿、二起腳、踢得又高又有力量，她精神飽滿，樣子年輕，令人羨慕，她還常常參加比賽，這證明運動有治療作用不是我一人的見證，生命在於運動是千真萬確。

還有一位朋友，他患上眼疾和脊椎沾黏疾病，因腰痛他四十多歲要躺在床上，眼睛不停流出黏液，有一隻眼睛己失明，另一隻也不太好，對他生活和工作影響甚大，最後一次他去找眼科醫生，醫生叫他不必再復疹，不必浪費金錢，因為他和其他眼科醫生都沒有方法治療他，但這醫生告訴他以前有一位相似病人，聽說後來去學打太極治好了，但不知她學什麼太極，醫生說他自己也不懂太極，結果這位朋友跑去公園看人家打太極，其實他也從未學過太極，結果選了一組他自己比較喜歡的武術，從此努力練功，結果有奇蹟出現，至今己有八年多，他身體自己產生的沾黏液體也消失了，剩下那隻眼睛也能一直保持視力，幸好他相信醫生的話，去學武術和打太極，沒想到打太極還能治好不治之症和救回一隻視力接近失明的眼睛，真的太不可思議了。

真可惜，我的兩個兒子都不相信太極有這麼好的效果，叫他們學習太極就說太忙沒時間，以前小兒子深夜看見我在客廳練太極，勸我千萬不要走火入魔，我等車或乘車在做手指纏絲動作，就細聲對我說，你忘記儀態了，小心別人以為妳精神有毛病，我沒什麼毛病，我的毛病只是一位超級武痴而已。現在無論他們怎樣想，我希望他們將來也會愛上太極，享受太極人生的健康和快樂。

感恩太極緣

　　相識是緣，每天能和拳友們一起練習太極拳是緣份，俗語說有緣千里來相會，無緣對面不相逢，感謝紅館太極康樂會的拳友們，有緣和大家相聚在一起，大家目標一致，為興趣、為健康、為快樂、為提高拳藝，為表演和比賽勤奮練習。大家由相識，相知，相約時間一起練習太極，練完上酒樓飲茶吃飯聊天，這種生活是何等愉悅，因為我們都是退休人士，兒女各有各忙，跟本沒時間陪伴，我們必需理解年輕人有他們的工作，也有他們自己的家庭負擔，我們要照顧好自己，自己找娛樂，有幸愛上太極，退休後才不愁寂寞，有拳友們一起打太極真的很開心，比起那些沒接觸太極的長者，我們真是幸運兒。

　　試想一想，香港有七百多萬人，能遇到這些熱愛太極、懂太極的太極拳友們，無論好天或雨天，住得遠或住得近，大家願意相約一起出來練太極，遲到會等妳，不見會關心你，這是多麼的難得和令人感動啊！雖然疫情有限聚令，但大家都沒偷懶，在家中依然勤練功，很期待疫情盡快結束，大家可以再見，對我來說，能出去打太極，是一種生活享受，心情也特別愉悅，但願有更多朋友接觸太極和愛上太極運動，共同享受太極帶給大家的快樂和健康。

　　除了愛打太極，我更愛比賽和表演，享受比賽的樂趣，比賽結果無論勝負，我都覺得有收穫，因為可以欣賞別人表演，認識來自不同國家的太極拳友，得獎固然開心，輸了也不會氣餒，最重要檢討失敗原因再努力，這樣才可提升技巧，拳術有了進步，才會希望再比賽，這種感覺

有如讀小學、中學或大學的學生，每天還在學習，活著有目標，有希望，有朋友一起玩，心情開朗，心態也變得年輕，可以說太極帶給我無限快樂，這年紀除了繼續追求太極拳藝，己別無所求。

人生只要你用心做了，輸贏都是精彩

在太極路上遇到很多朋友，也聽了很多故事，其實功夫兩字很易明，功夫是練出來的，悟出來的，誰也搶不了你的功夫，所以只要找到適合自己興趣的老師，能堅持、不怕苦，有自信，一定有成績。比賽只是遊戲，我見過有人因比賽成績不理想而影響心情，這樣就不要比賽，其實考試和比賽都是十分正向，對小孩、青年老年都是一種鼓勵，因為沒有考試或比賽就無法知道自己的進度。比賽可以激發奮鬥心，有了比賽，有了目標，心情也截然不同，我大孫女馨菲很期待每年的校際音樂節比賽，有比賽她會很開心，小朋友如是，我們大朋友也一樣期待太極比賽的日子，因為比賽場上可以見到很多朋友和拳友，比賽日子是開心大聚會，有場地給自己表演，也有拳友專誠入場棒場，氣氛熱鬧，因此我愛上比賽，我每年都會去日本或其它地區比賽，有人問，是否一定有獎，我的答案是否定的，主要是享受表演，也欣賞別人表演，遇見熟悉的拳友們很開心，就算語言不通，見面那種喜悅表情和心情真的難以形容，笑容就是大家最好的禮物和推動力。

比賽給我的很多感悟，人生有如一部小說，一場遊戲，一場夢，有得有失，有起有落，最重要是學會放下和寬心面對得失，因為所有懂得調

整心態的人最後都是勝利者。曾做了多年教育工作的我，對孩子的培養和教育有了豐富的經驗，因為經常接觸年輕人，所以講話像他們，想法接近他們，把學生成績看成我自己的考試分數，有優秀的學生也有平凡的學生，只要換位思考，也不會太失望，最後悟道盡力就好，品德第一，成績第二，順其自然，條條大道通羅馬，各有所長，將來各有發展前途，希望年輕家長們要重視孩子的能力，要考慮他們有否盡力，不要太重視分數，不要給自己和孩子太大壓力，不必為兩個數字大發雷霆，93 和 39 是暫時性。記得小兒子讀根德園幼稚園中班，有次回家滿臉羞愧，進門便拖著我的手走進房間，我問何事，他說昨天默書得 50 分，我問有多少人知道，他說隔離同學和前面那位和他自己有三個人知道，我問他們多少分，小兒說一個 80 分，另一個 90 分，我說不要緊，下次默書前提前溫習，如果有 80 分，你就最棒，因為 50 升到 80 多了 30 分，80 升到 100 只多 20 分，90 升到 100 也只多 10 分，所以老師一定會說你進步最大，他聽了很開心從房間走出來。這方法不一定是最好，但鼓勵是給孩子最大的自信，奉勸現代年輕父母不必為分數大發脾氣，最重要是有沒盡力而為，將來大家退休時，會覺得分數是微不足道，盡力就好，凡事只要用心做了，輸贏都是精彩，因為情商比智商更重要，而人品比成績更重要，學會寬心和放下才是人生真正的大贏家。

太極人生

最近疫情反復無常，人心惶惶，想想自己，己渡過人生三分之二的日子，雖然心態超級年輕，打起太極跳起來還以為自己正在讀小學，但細心數一數，未來日子好像還有一萬天左右，想起這一萬多天，心里有點擔心，擔心自己行動不自如，害怕身體有毛病連累忙綠工作的子孫，原來長命百歲並不是講那麼輕鬆，想活得快樂，一定要注意飲食，热愛運動，別把一輩子努力賺來的錢白白奉獻給醫生，除此之外，還要保持心境開朗，知足常樂，不要計較，寬心應對得失，多結交志同道合的朋友，這輩子我最大的收獲是打太極給我帶來的快樂，真的很感恩自己是一位熱愛太極者，現在的願望很簡單，可以天天出去打太極，有家人關心，己心感足矣。回想太極人生的日子，真的感到非常幸運，世上有各種各樣的遊戲，有不同的活動可以參與，我有緣接觸太極而且愛上太極，同時還在不斷追求太極的真諦，日子過得很充實，每天任務就是練太極。

太極博大精深，學無止境，一輩子也學不完，永遠有進步空間，如想提升技巧一定要有專業老師指點，有幸我找到適合自己的專業老師指導，嚴師要求嚴格，功夫才可更上一層樓，自信心也會大大提升，興趣也會大增和持續，根據本人學武術和學太極的經驗，無論學習太極拳或練習器械，最重要是先練好基本功，除了勤練，初學者還需注重慢練，單招練，還要通過體悟、漸悟和頓悟，這樣對套路的內容和拳理必定有更多發現，每位專業老師都有他個人的專長，所以如能集思廣益，必可集腋成裘。業餘學武者多數想接觸不同種類運動，增加樂趣，曾經是武

痴的我，想當年對什麼套路都想學，學了很多套路，不過都沒仔細研究，悟道其中的攻防意識，對那些套路內容也不甚了解，談什麼虛靈頂頸，四兩撥千金，用意不用力...等等的功防知識，幾乎是全不理解，動作都是體操形，不過這些都是初學者必須經歷的過程。其實有做體操總比沒做好幾倍，退休後如足不出戶，常呆在家中又不愛做運動，沒有社交群組，孤獨生活很易患上抑鬱症，所以人活著必須活動，要活就要動，有健康才會有快樂，身體健康才不會拖累家人和增添政府醫護人員的工作，這也是長者對家庭對社會的一種貢獻。

大家都知道，任何功夫都是欲速不達，但功夫不負有心人，只要用心勤練和體悟，一定有收獲，不過一定要巡序漸進，最重要是慢練，功夫是一點一滴累積得來的，而且要多悟多練多看示範，這樣功夫才可更上一層樓。 太極也令我悟道更多人生道理，凡事不強求，順其自然就好，以柔克剛四個字如應用在生活上是一種禮讓，柔可化敵為友，禮讓不是害怕而是有自信，看懂太極也看懂人生百態，招招式式變化多端，人生一樣多變化，如能學懂太極的內函，凡事觀察細微，眼光放遠，沉著應對，這樣人生一定會活得更快樂和更有意義，我有緣接觸太極，繼而愛上太極，可以說每天已沒有太多空餘時間，退休生活依然忙碌和精彩，自覺此生無悔！

在此我希望把自己學太極的小小知識和經驗，與大家分享，希望書本遇上有緣人，能引導更多人參與太極活動，令大家身體更健美和更健康，家庭更幸福，日子過得更快樂，這也是我寫這本書其中一個目的。

丁杰老師

余功保先生、黑志宏老師、劉彥英老師

傅清泉老師

冷先鋒師傅（日本）

宗光耀老師

日本常松勝會長、奚財林老師

香港南北國術總會會員到少林寺參加活動　　和梁淑卿教練到嵩山少林寺遊學

尹正華師父　　　　　　　　　　　李錦榮師傅帶領少林寺交流

崔仲三老師　　　　　　　　　　　李志明老師

張山老師、屈忠良老師

黃少貞師傅和梁淑卿教練

思雨師母

日本拳友

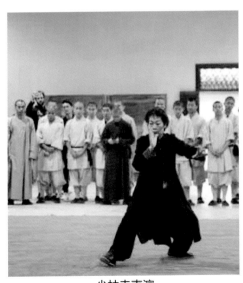

少林寺表演

梁先生和作者李嬋玲老師

紅館太極康樂會獲太極冠軍組亞軍

李文欽師傅

陳娟老師和陶曼紅老師

門惠豐老師

門敢紅老師

黃麗老師，顧建芬老師，李一萍老師

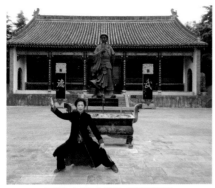

到陳家溝參觀和拜祖師爺

馬秀瑜老師、侯力壯教練

朱天才大師

徐廷陽藝術家

澳門比賽慶功宴

郝心蓮老師　　　　　　　　　　王培錕老師、馬春喜老師、陳國華老師

劉國勝師兄、呂頌棠師兄　　　　　　　　陳瑜師父

香港比賽第一名（太極刀）　　　　　　　陳世武教練

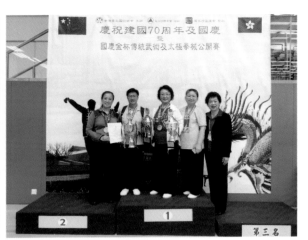

日本參賽　　　　　　　　　　　紅館太極康樂會隊員獲獎

馬俊祥老師、孫德玉老師　　　　　張保忠老師、陸長青老師

香港南北國術總會到陳家溝陳炳老師的
國際太極學院參觀和武術交流

2019年大媳婦獲頒優秀家庭獎
和親家孫女合照

梁洛菲孫女

陳瑜太極拳館教練陳偉權、黃湋、謝仰光和王粵軍教練

陳瑜師父和師兄師姐們

陳振楊老師、薛輝璐老師、
李珍珍師傅

陳瑜師父

山東師姐們（尹正華師父徒弟）

梁旭輝師傅　　　　　　　　　　趙志凌師傅

李錦榮師傅和羅麗萍師傅　　　　釋德希師父

郭東衞師傅和學生徐嘉祈　　　　楊合發老師

陪同馬春喜老師參觀陳國華師傅的武館

黃冬梅老師

門惠豐老師和闞桂香老師

香港屯門公園太極拳師兄師姐們

香港武術名家廖國承師傅和楊雲忠師傅

鄧文光和董繩周師兄，麥瑞芳和陳海梅師姐

冷先锋師傅

劉彥英老師、黑志宏老師

余功保先生

釋德希師父師母和李錦榮師傅帶遊少林寺

作者李嬋玲

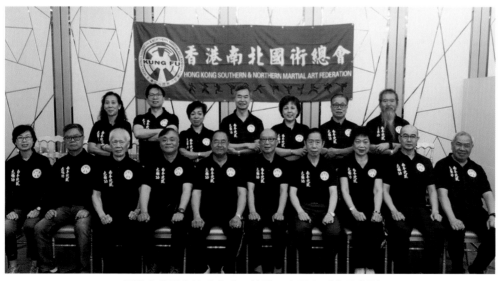

香港南北國術總會主席、總監、會長和副會長合影

目　　錄

1 第一式 預備勢
Preparation

■ 兩腳並步站立，左手抱刀，頭頂領勁，眼睛平視，耳聽身後，氣沉丹田（圖 1-1）。

Stand naturally with feet shoulder width apart and hands down. With the left palm embraces the Broadsword, keep the upper body free and supple. Sink the energy to the diaphragm and look forward spiritually.

1-1

第二式 起勢
Starting Form

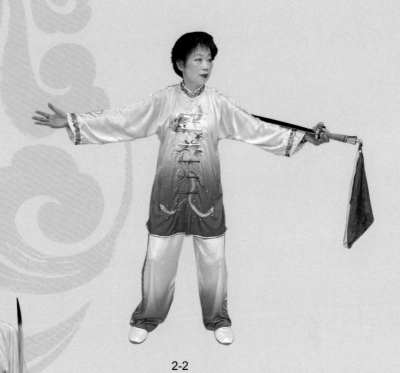

2-2

2-1

■ 左脚向左开步，與肩同寬，身體略下沉，雙手同時從左右分開上掤，腰微微右轉（图 2-1；2-2）。

The knees bend and sink slightly with both hands open from both sides of the body, and raise them upwards to shoulder level, then turn rightward and close them in front of the chest.

3

第三式 虛步抱刀

Embrace Broadsword in Empty Stance

■ 重心右移，左手持刀合抱於胸前，左腳上步成左虛步，注意兩
手合抱要圓和有掤勁感（圖 3-1）。

Move the body weight backward and rightward, then the left foot takes a step forward in empty stance, at the same time the left hand embraces the Broadsword in front of the chest and the right palm presses the left wrist and pushes it outward.

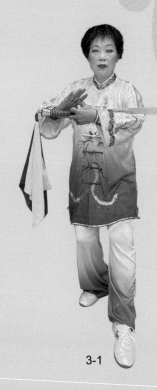

3-1

第四式 弓步藏刀
Hide broadsword in Bow Stance

4

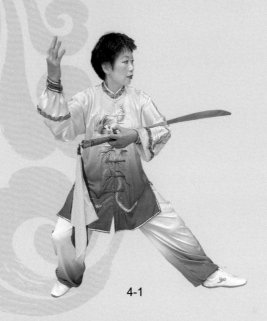

4-1

■ 身體微微左轉再向右轉，左腳上步成左弓步，右掌放在右額前方和太陽穴同高，右手隨身體左轉徐徐向前推出，左手持刀藏於左身旁（圖 4-1；4-2）。

Move the broadsword slightly leftward and rightward in an arc, with the right palm pushes slowly forward. Hide the broadsword behind the left knee in bow stance.

4-2

5 第五式 上步沖拳
Step Forward and Punch

■ 左手持刀環抱於胸前，右掌變拳從腰間沖出，左手持刀在上右手立拳在下，同時右腳活步向前上步，腳掌點地成右虛步，注意坐胯，重心在左（圖5-1）。

Embrace the Broadsword in front of the chest in an arc,the right palm becomes fist and punches forward from the waist, put it under the left wrist with the Broadsword above, at the same time,the right foot takes a step forward in empty stance.

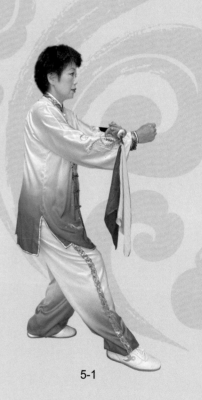

5-1

第六式 提膝抱刀

Embrace Broadsword with Raised Knee

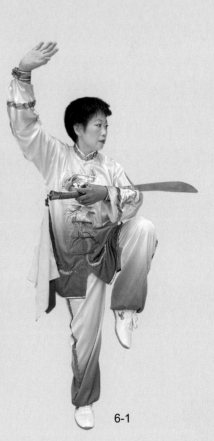

6-1

■ 重心右移，左腳上提與腰同高，左手持刀環抱胸前，注意手臂要向外掤，右手旋腕亮掌，頭頂領勁，目視左前方（圖 6-1）。

Move the center of body weight to the right foot, and lift the left knee to waist level, hold the Broadsword in front of the chest, notice the arm should ward off while the right palm lift upward. Keep the upper Body Free and Supple. Look forward.

第七式 左弓步扎刀

Stab in Bow Stance

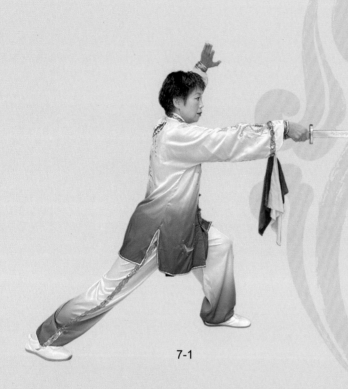

7-1

■ 鬆右胯，右腳往下沉，右手在胸前接刀，同時左腳落步向前跨
一大步成左弓步，右手握刀向前扎，左掌架於左太陽穴旁，眼
睛平視（圖 7-1）。

Bend the right knee and lower the left foot to the ground, the
left foot takes a stride forward,at the same time the right hand
takes over the Broadsword and stabs it forward, the left palm
stands near the temple chest. Look forward.

第八式 右弓步推刀
Push Broadsword in Right Bow Stance

8

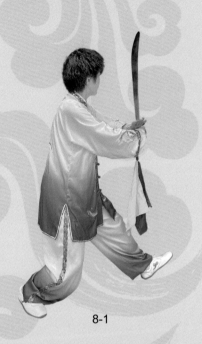

8-1

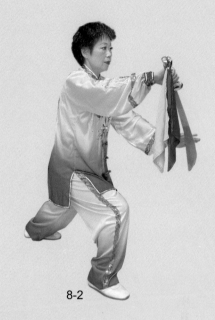

8-2

■ 重心後移，左腳跟外翻，右腳上步，右手帶刀上提向左劃弧，再向右前方推出，左掌虎口放在刀背上，注意膝蓋不能超過腳尖，推刀雙手不能撐得太直，背後要撐圓，要感覺有前後對拉勁 (圖 8-1；8-2)。

Move the center of body weight backward, the left foot swings outward, while the right foot takes a step forward in Bow stance, lift up the Broadsword and draw an arc from left to right, and then push forward, at the same time the left palm presses on the back of the Broadsword. Notice the right knee should not exceed the tiptoes, and the pushing hand should not be tight and straight. The back of the body should also be in circle. Look forward.

9

第九式 右弓步撩刀

Uppercut in Bow Stance

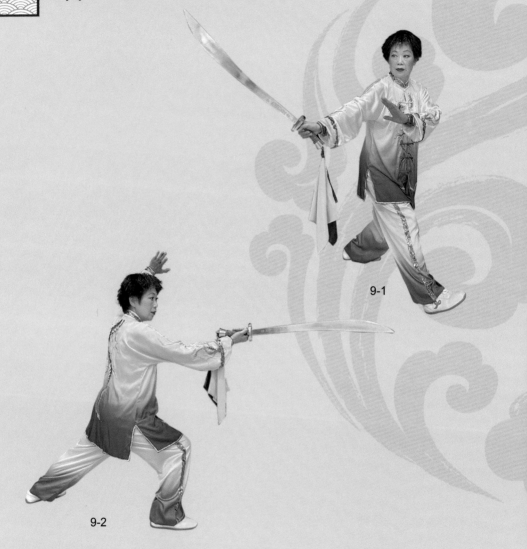

9-1

9-2

■ 重心後移，右腳跟外擺，右手持刀向右後方劃弧，左掌擺在右肩前，右手翻腕向前反撩時左腳上步，身体左轉，右腳上步成右弓步撩刀，動作連綿不斷，手隨腰轉，眼隨握刀手轉動（圖 9-1；9-2；9-3）。

第九式 右弓步撩刀
Uppercut in Bow Stance

9

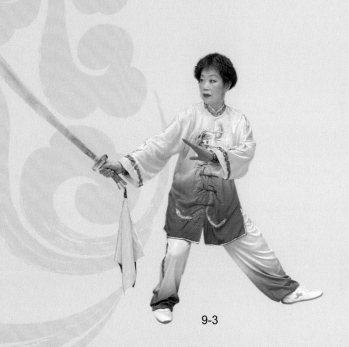

9-3

Move the center of body weight backward, with the right heel swings outward, the hand holding the Broadsword swings backward in circle, the left palm stands in front of the right chest, at the same time, turn the right wrist and uppercut Broadsword, the movement continues and the hand moves as the waist moves. Look directly to the point of the Broadsword.

10

第十式 左弓步推刀
Push Broadsword in Left Bow Stance

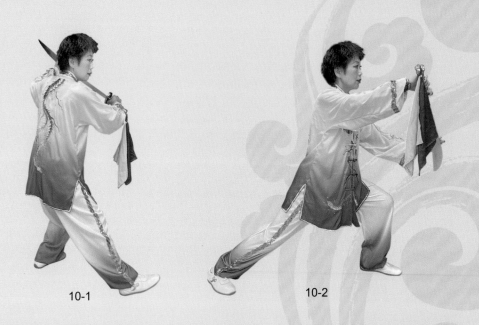

10-1 10-2

■ 重心左移，雙手帶刀向左上劃弧，再向下弧，右腳跟外擺約45度，動作連綿不斷，左腳向前上步成左弓步，雙手帶刀向前推，刀刃向前，左手貼在刀背上，右手持刀架在頭上方。注意推刀勢，右手要比左手高成斜線，右手高度在右額前方，這才有攻防作用 (圖10-1；10-2)。

Shift the body weight to the left, withdraw Broadsword and swing it upward and downward, the right heel swings outward in 45 degrees, the action continues, the left foot takes a step forward in Left Bow Stance, both hands push the Broadsword in front of the forehead with the left palm puts on the back of the Broadsword, the blade of the Broadsword faces outward. Notice that the Broadsword is not in horizontal, it is obliged with the point of the broadsword facing downward.

第十一式 右插步扎刀

Right Foot Back Cross-Step and Stab

11

■ 重心後移，左腳掌内扣，雙手帶刀向後劃弧，右腳向后插步，右手持刀從腰間向前扎，左掌向後撑形成對拉動作。注意身體不可向前傾（圖11-1；11-2）。

11-1

11-2

Move the center of body weight backward and swing the left tiptoe inward, draw the Broadsword backward in an arc, at the same time the right foot back-cross a step, withdraw the Broadsword from the waist and stab it forward, the left palm pushes leftward with left palm center faces outward. Notice the body should not lean forward. Look forward.

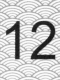

12

第十二式　並步劈刀
Chop Broadsword with Feet Together

■ 重心後移，左腳內扣，右腳跟內收，兩腿下蹲，右手持刀從左上向右下方劈時，左腳上提隨即震腳落地，左掌撐在左額前方，眼看劈刀方向，注意劈刀和震腳發力動作要同時完成（圖12-1；12-2）。

12-1

Move the center of body of weight backward, the left tiptoe swings inward while the right heel swings inward, bend both knees and stand with foot together, at the same time raise the left foot and stamp it on the ground quickly as soon as the Broadsword hacking downward, the left standing palm pushes outward. Look at the direction of Broadsword. Notice the action of stamping and hacking take place at the same time.

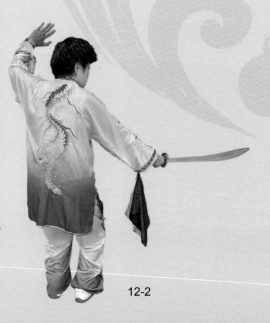

12-2

第十三式 架刀蹬腳
Support Broadsword and Front Kick

13

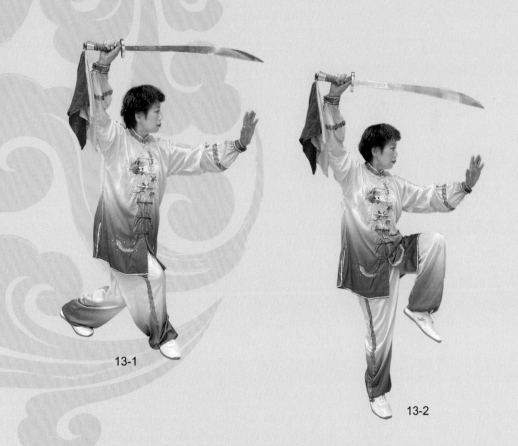

13-1

13-2

■ 重心右移，右手持刀向左上回帶向右下劃弧，左掌附於右肩前，這時身體繼續向右轉，右腳外翻，右手持刀上舉橫架於頭頂上方，同時左腿屈膝上提再向前蹬出，左手立掌從右肩前向前推出，右手持刀微向後拉，形成左右對拉動作，這樣持刀力量會更大，眼看前方（圖 13-1；13-2；13-3）。

13 第十三式 架刀蹬腳
Support Broadsword and Front Kick

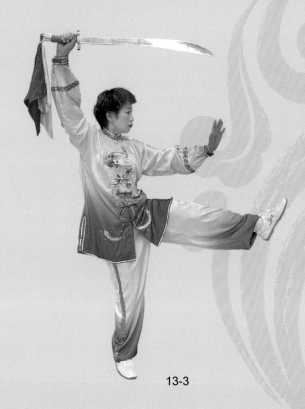

13-3

Shift the body weight to the right, swing the Broadsword upward and downward in circle , with the left palm stands near the right chest, the body keeps on moving to the right side , the right hand supports the Broadsword and blocks it overhead, raise the left knee to waist level and kick it forward with heel, the left palm center faces outward and pushes forward while the hand holding the Broadsword pulls backward which makes a pull and push force. Look forward to the left palm direction.

第十四式 落步藏刀
Hide Broadsword in Bow Stance

14

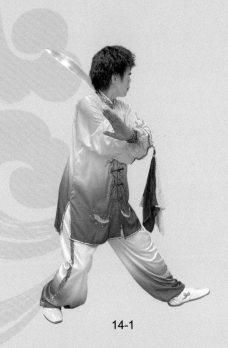

14-1

■ 左腳跟落地，右手持刀收於左腋下，手心向下，刀刃向外，左掌劃弧擺在右肩前，眼看前方（圖14-1）。

Drop the left heel on the ground slowly withdraw the Broadsword and hide it beneath the armpit, with the right palm center faces downward and the blade faces outward, the left palm stands in front of the right chest.

第十五式 纏頭裹腦
Twine and Wrap Around Head

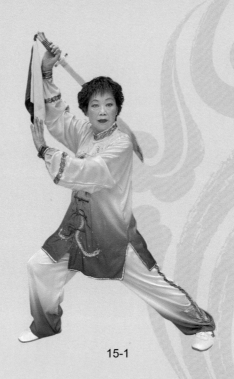

15-1

■ 左腳內扣，身體右轉，右腳跟向右前方落步，右手持刀從左肋向右平掃，順勢臂外旋，屈肘上提，刀背向身後，刀刃向外，經右肩向左肩外側繞行，左手立掌附於右肩前，眼看正前方。注意裹腦，刀背要緊貼肩繞行（圖 15-1）。

The left tiptoe swings inward while the right heel swings outward, the broadsword rotates from right shoulder to left shoulder, with the back of the Broadsword faces inward and the blade faces outward, put the left standing palm in front of the chest. Notice the back of the Broadsword should move closely around the back from left to right. Look forward.

第十六式 弓步藏刀
Hide Broadsword in Right Bow Stance

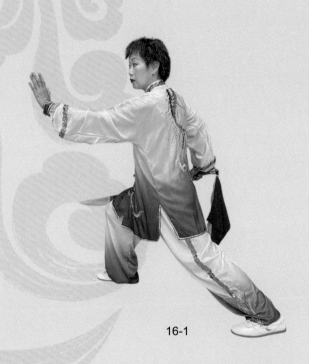

16-1

■ 接裹腦動作，右腳落步成右弓步，右手持刀從左肩向下拉到右膝外側，注意刀尖不可超過右腿，左掌從左肩前向中心線推出，眼看左掌上方（圖 16-1）。

It starts from twine and wrap head with Broadsword, twine the Broadsword from the left shoulder to the right shoulder and hide it behind the right leg the left standing palm pushes forward from the middle of the chest. Look forward.

17 第十七式 蓋步纏頭

Front Cross Step and Twine and Wrap Around Head

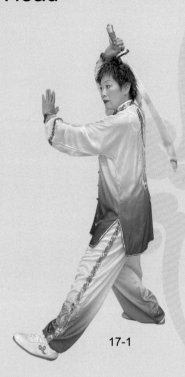

17-1

■ 左腳向左前方上步，兩手合於胸前，交叉上舉，右手在內，左手在外，順勢右臂屈肘內旋，刀背向后，刀刃向外，刀尖下垂，刀背緊貼肩背，沿左肩向右肩劃弧纏頭（圖 17-1）。

The left foot takes a step forward, close two hands in front of the chest and then lift them above head,(with the right hand inside and the left hand outside), at the same time, bend the elbow and rotate the wrist of the right hand, twine the Broadsword from left shoulder to right shoulder, with the blade of it facing outward and point of it facing downward, during rotation the back of the broadsword should close to the back .

第十八式 弓步藏刀打虎勢
Hide Broadsword in Bow Stance with Beating Tiger Posture

18

18-1

■ 右腳向左腳前蓋跳, 兩手在胸前交叉上舉, 右臂順勢屈肘內旋, 刀尖向下, 刀背緊貼肩背, 經左肩向右肩劃弧繞行, 平掃收到左肋, 左掌變拳架在左額前, 拳心向外, 拳眼向下, 成左打虎勢, 眼看右前方 (圖 18-1) 。

The right foot leaps a step over the left foot, close two hands in front of the chest and lift them overhead, bend the right elbow and rotate the Broadsword from left shoulder to the right shoulder, with the point of the Broadsword facing downward and the blade of it facing outward, change the left palm into fist and put it in front of the left forehead to defend the head, notice the center of fist faces outward in a beating tiger posture. Look at the direction of the broadsword.

第十九式 蓋跳步截刀
Cross a Step and Hack downward

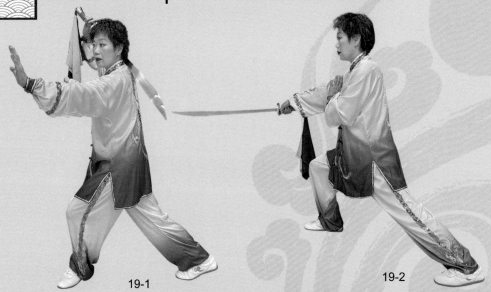

19-1　　　　　　　　19-2

■ 接打虎式，右腳上步，左腳同時向右腳前蓋跳步，左手變掌立於右肩前，右手持刀從左肋下向右上方劃弧，隨即屈腕從右肩向左裹腦，刀背貼身，刀尖下垂，刀刃向外，同時右腳再向右前方上步成右弓步，右手持刀經胸前向右下方截刀，注意下截刀要平，刀尖只可微微向下，同時左掌心外撐，成左右對拉勁，眼看右前方（圖 19-1；19-2）。

It starts from beating tiger posture, the right foot takes a step forward, at the same time the left foot leaps a step forward in front of the right foot, the left palm stands upright in front of the right shoulder, draw the Broadsword upward from the left underarm to the right shoulder, the blade faces outside, the point of Broadsword faces downward, then twine and wrap the head and sweep it in an arc to the right knee, hack it forward above kneel level, with the left palm pushing backward, making both hands in a pull and push effort . Look forward to the right front.

第二十式 上步絞刀
Step Forward and Rotates Broadsword in front of the Body

20

20-1

20-2

■ 接弓步截刀，重心在右，身體左轉，左腳向前上步，右手持刀和左掌合於胸前，左手輕按刀背，隨腰從左到右劃一大圓後，在胸前再劃一小圓，然後右腳上步先提膝再震腳。注意第二次小圓絞刀和震腳時間要一起完成，眼隨刀轉，絞刀時是刀隨腰動划圓，不是手動腰不動（圖 20-1；20-2）。

The center of body weight still on the right, turn left as the left foot takes a step forward, both hands close in front of the chest, the left hand presses on the back of the broadsword , then rotate the Broadsword in front of the body in a big circle first and then a small one, then raise the right foot and stamp it on the ground heavily, at the same time stab the Broadsword forward. Look forward.

21

第二十一式 左弓步扎刀

Stab in Left Bow Stance

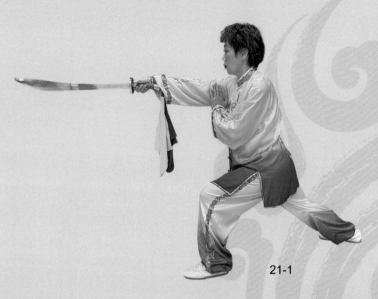

21-1

■ 接墊步絞刀，左腳上步，身體微左轉，右手持刀向左前方扎出，左掌劃弧收回立在右肩前，注意刺刀，要先蓄勁後才發力，力要從腳到腰到手發出，這樣刀的聲音出來才會更響亮，同時注意身體不能因為發力而前趴，右手持刀高度與肩平行，同時保持虛靈頂頸，發力時眼睛放遠，同時要虛靈頂勁，雙目有神（圖21-1）。

The left foot takes a step forward, and the body turns slightly to the left, the hand holding the Broadsword stabs forward , withdraw the left standing palm and put it in front of the right shoulder, notice it is important to exert the force before stabbing , the force comes through the foot to the waist and to the hand and then to the point of the Broadsword . To make the sound come out from the Broadsword clearer and louder, we need to hold it firmly,avoid the body incline to the front, the Broadsword is parallel to shoulder level, keep the upper body Free and Supple. Look forward spiritually.

第二十二式　丁步點刀
Point Broadsword in T-Step

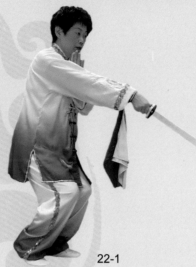

22-1

■ 右腳上步，腳跟著地，左掌劃弧收回立於右肩前，右手持刀翻腕，向左右撩，向右後撩時掄臂向右前，兩手合於胸前，左手掌心壓在右手腕背上，隨即左腳提膝上步，前腳掌點地成丁步，兩腿屈膝半蹲，右手持刀向前下方點，點刀時腰微左轉，力從右腳跟至腰到肩及手發出，注意左手前掌要輕壓右手腕背，以穩定點刀力量，眼看刀尖前方（圖 22-1）。

The right foot takes a step forward, the heel drops to the ground, withdraw the left palm in an ac and put it in front of the right chest, turn the wrist inward and swing the Broadsword upward and draw circle downward from left to right, and vice versa, close two hands in front of the chest, the left palm presses on the back of the right wrist, whilst raise the left knee and step forward, the front foot touches the ground in T-step, then squat down with bending knees, exert force and stab downward, the force comes from the heel to waist, and from the waist to shoulder, then from shoulder to hand. Look at the point of the Broadsword.

23 第二十三式 後撩腿扎刀
Back kick and Stab

■繼丁步點刀勢，提左膝，收右胯站立，同時左右兩手合抱，左手抱住右手，雙手持刀上提收到胸前，左膝上提至腰，然後左腳徐徐向後撩起，上身徐徐向前探出，雙手持刀伸直向前扎，注意頭要抬起，前后要有對拉勁，這樣才能保持平行和站穩，目視正前方（圖23-1；23-2）。

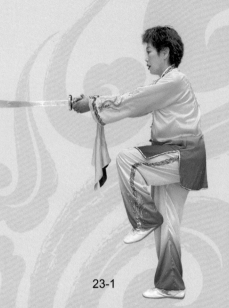

23-1

It starts from pointing the Broadsword in T- step, raise the left knee to waist level, loosen the hip and stand on one leg , close two hands in front of the body, the left palm embraces the right wrist, raise both hands up to chest level whilst the left knee raises to waist level , the left heel kicks backward as soon as the body pushes forward and stab, the push and pull force helps balancing the body. Look forward directly.

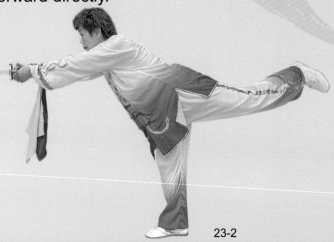

23-2

第二十四式 跳步扎刀
Leap Forward and Stab

24

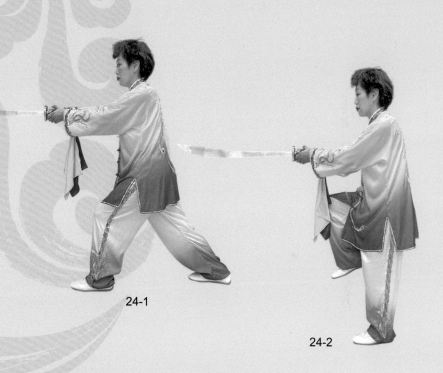

24-1

24-2

■ 左腳向前落步的同時，把刀收回右腰間，右腳向前跳步的同時向前扎刀（圖 24-1；24-2）。

(a) The left foot takes a step forward, withdraw the Broadsword to the right side of waist,the right foot leaps a step forward and stabs the Broadsword directly to the front.

24 第二十四式 跳步扎刀
Leap Forward and Stab

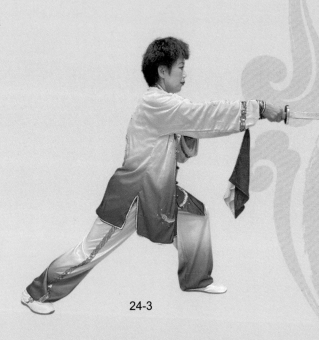

24-3

■ 左腳上提向左轉180度，左腳上步，右手持刀經腰旁向前平扎，左掌撐在右臂彎內側，目視前方（圖24-3）。

(b) The right heel swings inward, the body turns left in 180 degrees, the left foot takes a step forward, the hand holding the Broadsword stabs forward horizontally through the waist, the left palm pushes outward in front of the right chest. Look forward.

第二十五式 提膝扎刀

Raise Knee and Stab

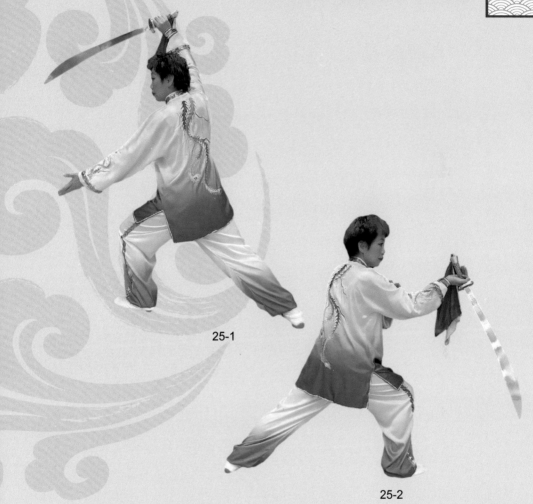

25-1

25-2

■ 左腿上提，右腿直立，右手帶刀掄臂，做一個腕花，然後收刀於腰間，先蓄勁再向斜下刺刀，左掌向左上方撐，掌心向前，形成左右對拉勁。要求力達刀尖和指尖，眼看持刀斜前方（圖25-1;25-2;25-3）。

25 第二十五式 提膝扎刀
Raise Knee and Stab

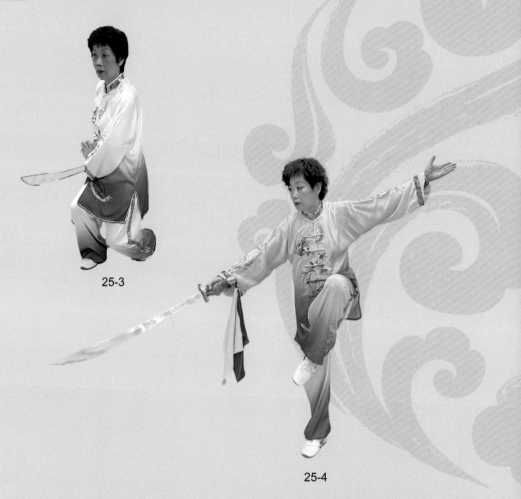

25-3

25-4

Raise the left knee up to the waist level, stand on one leg and draw the Broadsword upward and downward and swing a 武花 , then withdraw the Broadsword behind the waist, exert force and then stab the Broadsword downward, the left palm pushes leftward with palm center facing outward forming a pull and push force. The force exerts at the point of the Broadsword. Look directly to the point of Broadsword.

第二十六式 右弓步推刀

Push Broadsword in Right Bow Stance

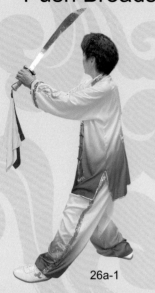

26a-1

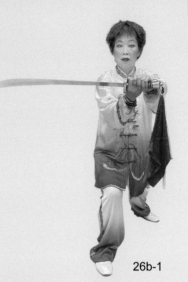

26b-1

■ 26a，左腳落下和右腳並步，右腳跟外展，右腳掌內扣，右手持刀翻腕，拳心向上，刀尖向右，左掌按在刀柄上（圖26a-1）。

■ 26b，重心左移，左腳掌內扣，右腳跟外翻，然後左腳向右腳前上步，身體右轉約270度，此時右腳提起向前跨一步成右弓步，身體帶刀右轉，右手持刀從腰間提起到胸前再向前平推，注意左掌是握著刀柄，刀刃向外，刀尖向右，眼睛平視推刀方向（圖26b-1）

The left foot drops behind the right foot, the left tiptoe swings inward whilst the right heel swings outward, carry the Broadsword in front of the chest and turn around 270 degrees,with the point of it pointing to the right and the Blade of it faces outward, notice the left palm is holding on the handle of the Broadsword, exert force and raise it from waist to chest level, then push it forward in right Bow Stance. Look forward spiritually.

27 第二十七式 弓步平推
Push Broadsword Forward in Left Bow Stance

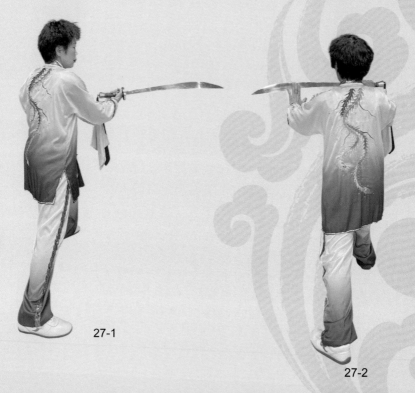

27-1

27-2

■ 身體左轉, 右腳掌內扣, 左腳上步成左弓步, 右手持刀向左劃弧, 同時翻腕收回腹前再向前平推, 刀刃向外, 左掌虎口輕按刀背, 眼睛平視正前方 (圖 27-1; 27-2)。

Turn left immediately, with the right tiptoe swings inward, the left foot takes a step forward in Bow Stance, the hand holding the Broadsword draws an arc to the left, turn the wrist and withdraw the Broadsword to the abdomen, the left palm presses on the back of the Broadsword then pushes outward slowly, with the Blade facing outward. Look forward.

第二十八式 彈踢反撩
Snap Kick and Uppercut Broadsword

28

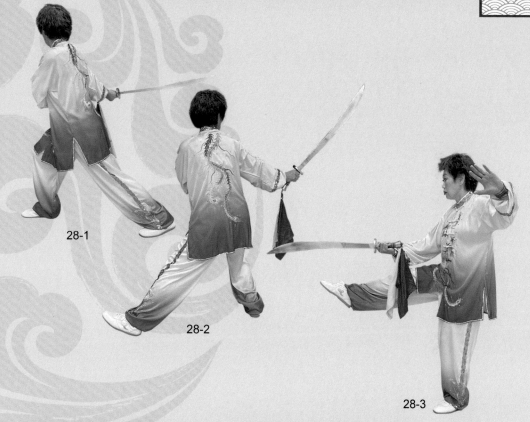

28-1

28-2

28-3

■ 右腳向左前蓋步，持刀手隨腰轉上舉向右後方劈刀，右掌附於右肩前，隨即左腳上步，右腳提起彈踢，腳面繃直，左掌心外撐，眼睛平視前方（圖 28-1；28-2；28-3）。

Raise the left knee up to the waist level, stand on one leg and swing the Broadsword upward and downward, then withdraw the Broadsword behind the waist, exert force and then stab the Broadsword downward, the left palm pushes leftward with palm center facing outward forming a pull and push force. The force exerts at the point of the Broadsword. Look directly to the point of Broadsword.

29

第二十九式 提膝截刀
Raise Knee and Cut

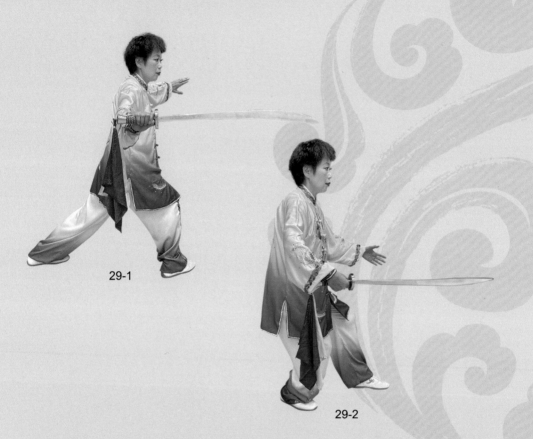

29-1

29-2

■右腳向後撤步，與此同時右手持刀做一個腕花，身體右轉
180 度，左腳掌內扣，兩手向兩側分開，右腳再向後撤時，
兩手劃弧合於胸前時，左膝上提成獨立步，兩手再向左右兩
側分開落兩胯旁，兩手臂撐圓，右手持刀扣腕，刀刃斜向外，
站立時要收胯，這樣才能左右合住和站隱，同時要虛靈頂頸，
眼睛平視遠方（圖 29-1；29-2；29-3；29-4）。

第二十九式　提膝截刀
Raise Knee and Cut

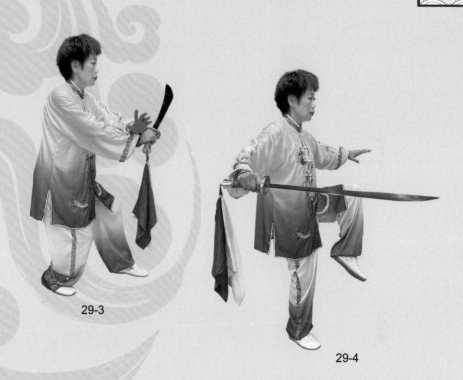

29-3

29-4

After the snap kick ,retreat the right foot and turn around 180 degrees with the left tiptoe swings inward ,swing a small Wuhua (武花)and close two hands in front of the chest ,then the right foot takes a step backward, raise the left knee and stand on one single leg, then separate both hands to each side, notice the blade of the broadsword is facing outward, and the wrist of the right hand buckles inward, both hands are warding off in circle, the relaxing of the thighs and bending of the single standing knee will help closing the power and balancing the body, remember to Keep the upper body Free and Supple. Look forward directly.

30

第三十式 纏頭掃刀
Wrap Around Head and Sweep Broadsword

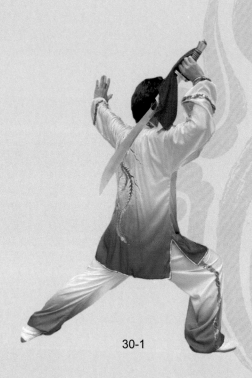

30-1

■接分刀姿勢，左脚跟落地，右脚上步內扣，右手持刀翻腕上舉，刀尖下垂，右手持刀從左到右劃弧纏頭，刀背緊貼肩背，身體從左旋轉 360 成左弓步推刀（圖 30-1；30-2）。

第三十式 纏頭掃刀
Wrap Around Head and Sweep Broadsword

30

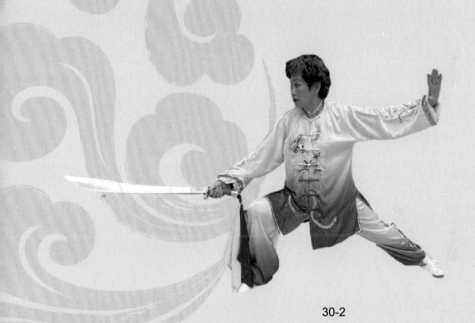

30-2

The heel of the left foot drops on the ground, the right foot takes a step with the tiptoes swing inward, the hand holding the Broadsword turns the wrist and lift it over the head, then rotate the broadsword from left to right with the tip of Broadsword facing downward, the back of the broadsword must close to the back during rotation, the body turns left in 360 degree in right Bow stance. Look forward.

31 第三十一式 仰身推刀
Lean Back and Chop

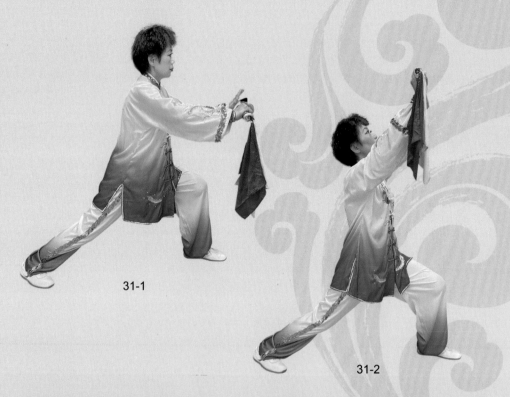

31-1

31-2

■ 接左弓步推刀，重心後移，頭和身體后仰，左手和右手持刀緊貼胸前上舉到額前，同時向左右兩邊分開，刀尖向左，刀刃向外，眼隨持刀動方向（圖 31-1；31-2）。

Shift the center of the body weight backward, the head and body lean backward, the left hand and the hand holding the broadsword close in front of the chest, then raise them up and separate them above head, then close them and cut leftward in front of the body, the left palm holds the right hand near the wrist ,notice both hands should ward off in circle, Look forward.

第三十二式　弓步平斬
Hack Broadsword in Bow Stance

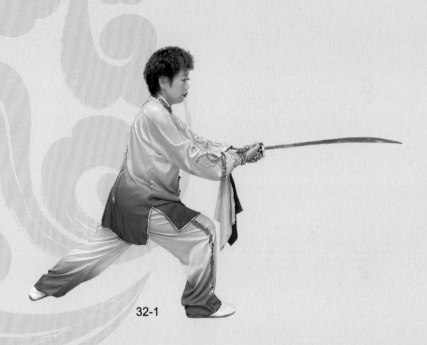

32-1

■ 接仰身推刀后，右腳向前上一步，兩手劃弧同時合抱於胸前，刀刃向左平斬，右手心向上，左掌托在右腕下，眼看前方（圖 32-1）。

It starts from lean back and chop, the right foot takes a step forward, swing the Broadsword in circle and close it in front of the chest, the Blade faces leftward, the point of the Broadsword facing upward and forward, the left palm support under the right wrist. Look forward.

33

第三十三式　背花反撩
Swing Broadsword 3 times and Upper Cut

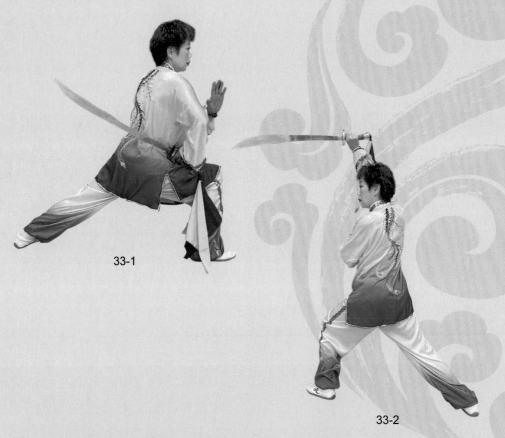

33-1

33-2

■ 刀隨身體左右回轉，右手持刀從右下落到左，再從左向上劃一立圓，做完三個腕花刀後把刀背貼在後腰間，身體左轉，右手持刀向後立圓掄劈，刀刃向下，眼隨刀轉，左腳向右後叉步成左歇步，右手持刀從下向上反撩，左掌貼在右腕上（圖33-1；33-2；33-3；33-4）。

第三十三式　背花反撩

Swing Broadsword 3 times and Upper Cut

33

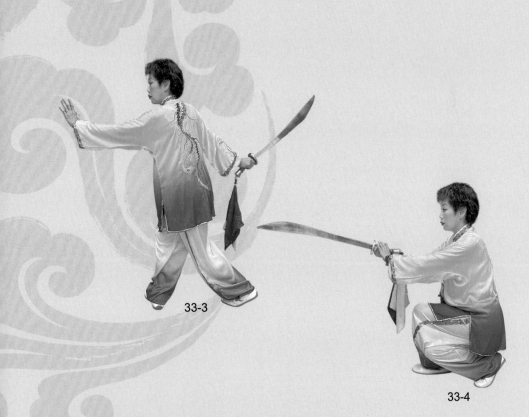

33-3

33-4

Swing the Broadsword and repeat Wuhua(武 花) 3 times in front of the body, the waist moves as the broadsword cuts left and right, then the hand holding the Broadsword draw a big circle and uppercut in resting Stance with the left palm presses on the right wrist .Look forward.

34 第三十四式 並步扎刀
Stab Broadsword with Feet Together

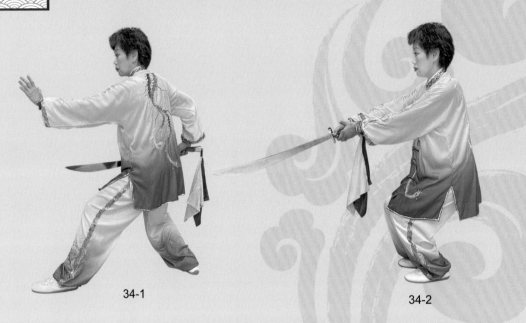

34-1

34-2

■ 身體徐徐上提，右手持刀速度做一個腕花刀，同時刀向後拉，左掌向前推，右腳向后退一步，此時左腳掌外翻，右手持刀經腰間向前扎出，注意兩肩放鬆，同時重心前移，右腳上步提膝，隨即在左腳內則下落震腳，左掌輕按右腕上，目視前下方（圖34-1；34-2）。

Raise up the body slowly, the hand holding the Broadsword swing a small circle backward and upward,then pull back the Broadsword behind the waist, the right foot takes a step backward, the left palm pushes forward, exerts force and stab through the waist, move the body centre forward, raise the right foot and stamp beside the left foot, the left palm presses on the wrist of the right hand. Look at the direction of the of Broadsword.

第三十五式 右弓步腕花刀

Swing Broadsword in Right Bow Stance

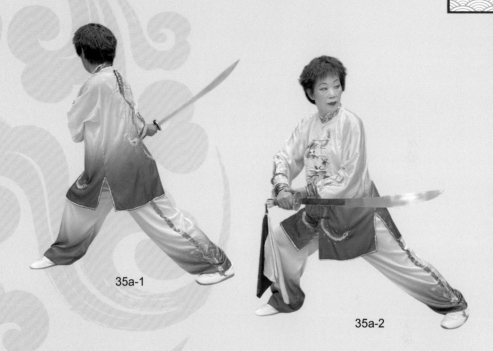

35a-1

35a-2

■ 上右腳成右弓步，右手持刀在上，左手托著右手腕，做左右三次腕花刀，注意身體帶腰帶刀轉動，身體和刀要協調配合，腰要柔，手腕要鬆，這樣才能表現出輕靈、圓活、自然和美觀 (圖 35a-1；35a-2) 。

The right foot takes a step forward and become Right Bow Stance, the left palm support under the wrist of the right hand with the Broadsword. Swing the Broadsword Wuhua(武 花) 3 times, notice the Broadsword moves as the waist moves, and the waist moves as the body moves, the moving of the Broadsword depends on the move of the body and waist, the waist and the wrist should be soft and relax, so it looks more agile, living and natural and beauty.

35 第三十五式 馬步架刀
Swing Broadsword in Bow Stance

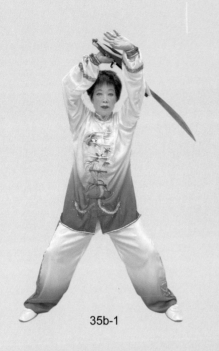

35b-1

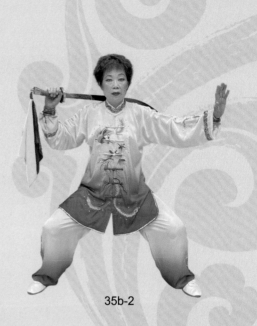

35b-2

■ 重心左移，右腳收回與左腳平行成馬步，兩手交义上舉，右手持刀從左肩纏頭平架在右肩上，刀刃向外，左掌外撐，掌心向外，眼隨刀轉（圖 35b-1；35b-2）。

Move the centre weight leftward, withdraw the right foot in Horse Stance, close two hands in front of the body and lift the Broadsword overhead, draw the Broadsword from left and rest it on the right shoulder, with the Blade facing outward, the left palm pushes outwards. Look forward.

第三十六式 翻身起跳掃刀

Turn Around and Take Off and Hack

36

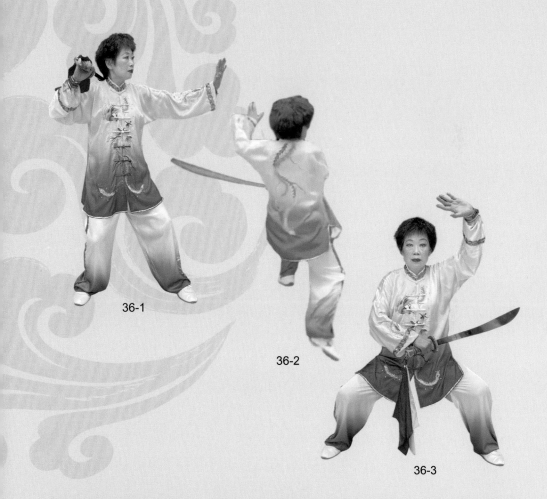

36-1

36-2

36-3

■ 身體微微左轉約 45 度，再右轉 90 到右側旁，與此同時身體
徐徐下蹲，利用左右旋轉的螺旋勁，左腳上提，右腳掌內扣，
向左翻身起跳，起跳旋轉時右手持刀從右平掃收到左肋旁，
左手撐在左額前（圖 36-1；36-2；36-3）。

36

第三十六式　翻身起跳掃刀

Turn Around and Take Off and Hack

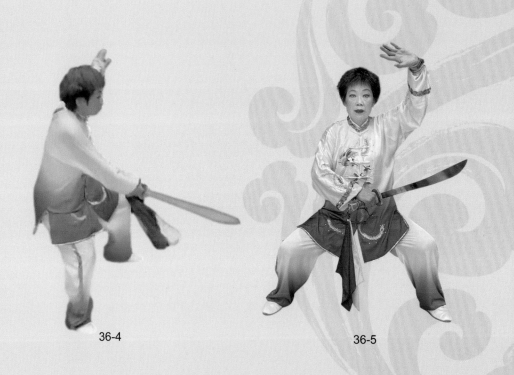

36-4 36-5

Turn the body leftward and then rightward about 90 degrees, at the same time relax the thigh and bend the knee, make use of the spiral volution force of unwinding, raise the left knee to waist level,turn left and jump with the body rotate in270 degrees, the hand holding the Broadsword sweeps horizontally and in circle, the left unfolding palm pushes leftward.

第三十七式 回身左弓步掄劈
Turn Round and Hack in Left Bow Stance

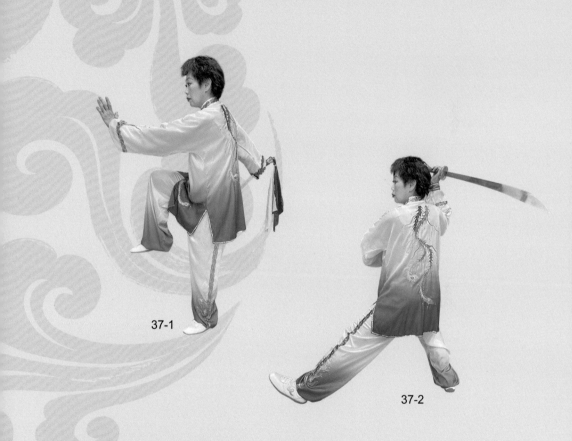

37-1

37-2

■ 隨即身體右轉，右腳活步，左腳向右方上步成左弓步，右手持刀從左肋向后平拉，劃弧上提要立圓，向前劈刀時力達刀的前刃，左手撐在右額前，掌心向外，眼看劈刀方向，劈刀結束時注意臂與刀成直線（圖37-1；37-2；37-3）。

37 第三十七式 回身左弓步掄劈
Turn Round and Hack in Left Bow Stance

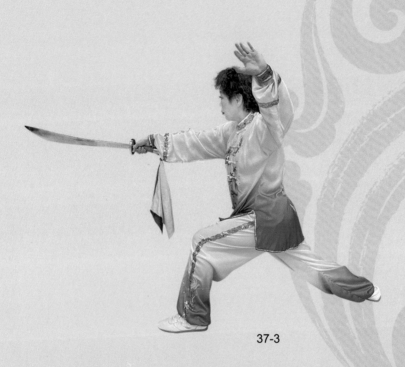

37-3

Turn right and the right foot takes an active step, while the left foot takes a step forward and become left Bow Stance, draw the Broadsword backward and upward in circle, then hack forward, make sure the hacking force exerts in the front of the Blade, the left hand pushes leftward with palm centre facing outward, look at the hacking direction, notice the arm and the Broadsword form a straight line.

第三十八式 轉身二起腳

Jump with Double Raise Feet

38

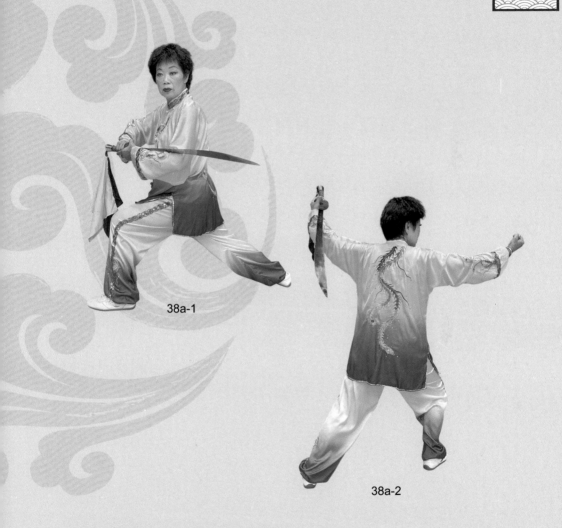

38a-1

38a-2

■ 重心後移，右手屈腕交刀左手，左腳內扣向右後轉身180度，
右腳向後撤一步，此時左手抱刀上舉，右手掌變拳下隨（圖
38a-1；38a-2；38a-3）。

38 第三十八式 轉身二起腳
Jump with Double Raise Feet

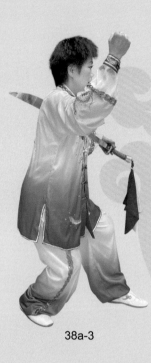

38a-3

Move the centre of body weight backward, bend the right arm to let the left hand take over the Broadsword, the left tiptoe swings inward and turns rightward about 180 degrees, the right foot retreats a step, the left hand raises the Broadsword upward, the right hand drops down with the fist face faces downward.

第三十八式 轉身二起腳
Jump with Double Raise Feet

38

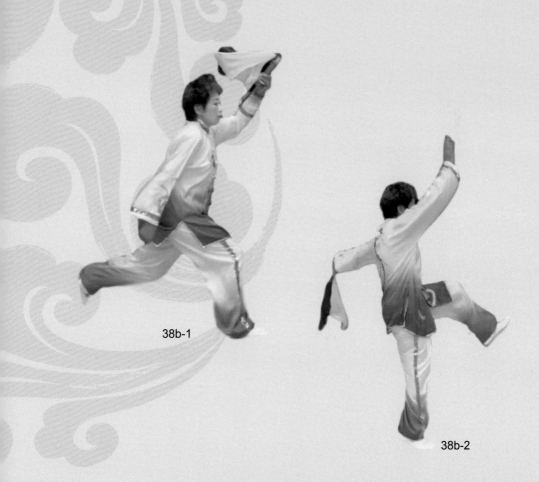

38b-1

38b-2

■ 右腳上步，左腳跳起時右腳提膝向上向前彈踢，右臂隨身體轉動立圓向前掄臂，右手變掌迅速擊拍右腳前掌面，左手抱刀放在左腰旁，眼看前方（圖 38b-1；38b-2；38b-3）。

38

第三十八式 轉身二起腳
Jump with Double Raise Feet

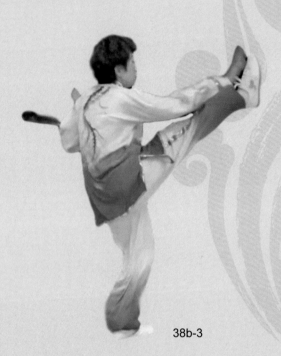

38b-3

The right foot takes a step forward, the left knee raises to waist level, the right foot jumps up and kick forward with straight foot and pointing toes, the right palm swings a circle and slaps on the right foot quickly, the left hand embraces the Broadsword beside the left waist. Look forward and keep the upper body Free and Supple.

第三十九式 撲步按刀

Press Broadsword in Crouch Stance

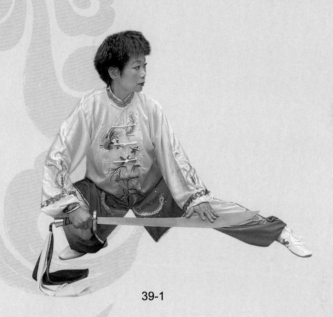

39-1

■ 接右手拍右腳面，右腳落地，右手接刀做一個右腕花，手腕放鬆向右翻腕，刀尖向下向後劃圓，兩腳離地交替上跳，身體微右轉，右腳先落地，隨即鬆胯屈膝下蹲，左腳同時向左擦步成撲步勢，右手持刀下截，刀刃向下，刃尖向前和左腳平行，左手掌心按在刀背上，眼看左前方（圖 39-1）。

It starts from slapping the right foot, as soon as the right foot drops on the ground, the right hand takes over the Broadsword and swings it up and down in a circle, then crouches down with the left palm presses on the back of Broadsword in Crouch Stance. Look at the direction of the point of the Broadsword.

40

第四十式 弓步扎刀
Stab in Bow Stance

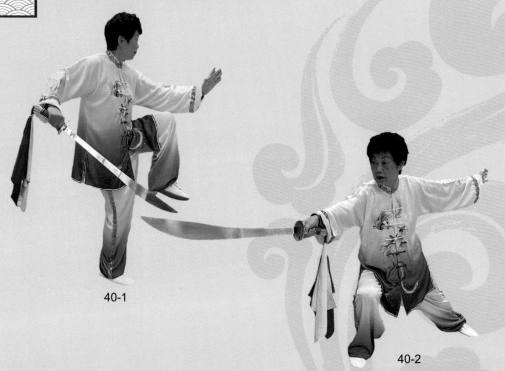

40-1

40-2

■ 接撲步按刀，身體起立重心右移，左腳上提與腰同高，左手前推，左腳隨即落地，右手持刀向前刺，再向後砍，迅速右腳上步，右手持刀向前撩刀，左手向後撐，形成對拉勁，眼看前方 （圖40-1，40-2）。

It starts from pressing the Broadsword in Crouch Stance, shift the centre of body weight rightward, raise the left knee and then drop it on the ground slowly , the hand holding the Broadsword stabs forward and hacks backward immediately, then turn left and uppercut forward in Bow Stance with the left palm stretches leftward , forming a pull and push effort. Look forward.

第四十一式　馬步推刀
Parry in Horse Riding Stance

41

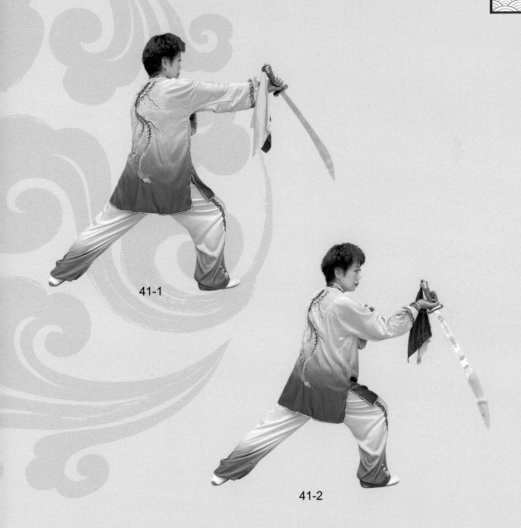

41-1

41-2

■ 左腳掌外翻，右腳上步，隨即在胸前做腕花，然後右手持刀收
回右肩旁，左手立掌在右肩前，同時變馬步，右手持刀扣腕立刀，
發力向右推出，刀尖向上，刀背向內，刀刃向外，左手掌向外撐開，
成對拉勁（圖 41-1；41-2；41-3；41-4）。

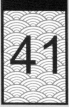

第四十一式 馬步推刀

Parry in Horse Riding Stance

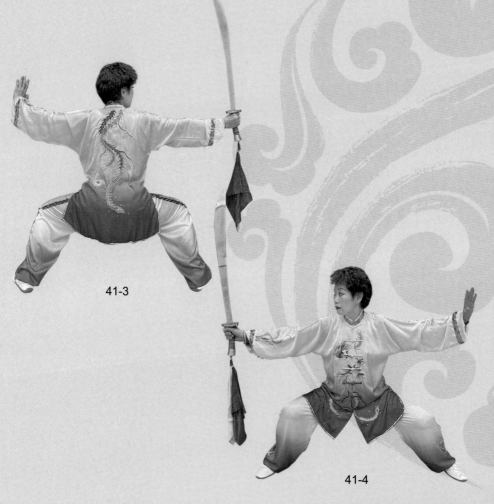

41-3

41-4

The left tiptoe swings outward, the right foot takes a step forward, swing a small Wanhua (腕 花)in front of the body and push it forward ,with the point of Broadsword standing up and the blade of it faces outward in horse riding stance, the left standing palm pushes leftward ,forming a pull and push action. Look rightward.

第四十二式 披身格刀
Block Broadsword with body oblique

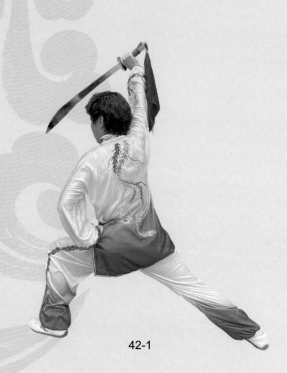

42-1

■ 右手持刀翻腕經右額前向左前方斜推，刀刃向上，刀背向下，左手叉在左腰成左弓步掛刀勢，眼看左前方（圖42-1）。

It starts from parry in horse riding stance, the body turns leftward, turn the wrist inward and push the broadsword upward with body oblique to the left, the blade of the broadsword faces upward, while the back of it faces inward, the left hand akimbo the left waist in Left Bow Stance. Look at the point of the Broadsword.

43 第四十三式 左插步劈刀
Left Foot Back Cross-Step and Hack

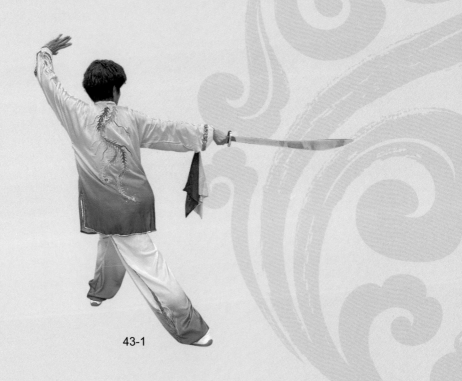

43-1

■ 接披身斜掛動作，右手持刀向右後方劈刀，與此同時左腳向後插步，左掌撐在左額前，掌心向外，劈刀手要平，目視右前方（圖43-1）。

The left foot crosses a step behind the right foot, at the same time the hand holding the broadsword draws backward and hacks horizontally to the right side, the left palm stands near the left side of the forehead, with the center of the palm facing outward, look backward.

第四十四式　轉身纏頭掃刀

Twine and Wrap and Sweep Broadsword

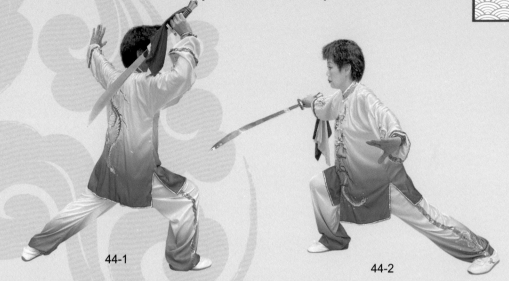

44-1

44-2

■ 身體向左旋轉 180 度，右腳掌內扣，左腳掌外展，右手持刀隨身體旋轉 180，兩手在胸前交叉上舉，右手持刀在上，左掌在下，做纏頭動作，右手持刀上提屈腕，刀尖下垂，刀背緊貼肩背纏繞，纏頭動作是刀從左肩划弧到右肩，然後收到左腋下，刀刃向下，左掌撐在左額前方，眼看前方（圖 44-1；44-2）。

It starts from Back Cross Step, turn 180 degrees leftward, the right tiptoe swings inward, while the left tiptoe swings outward, both hands close in front of the chest and then lift them up, with the left palm center faces outside, then twine and wrap around the head, with the blade facing outside, and the back of the Broadsword close to the back, move it from left shoulder to right shoulder, then continue to draw it to the left side and hide it under the left arm, the left palm stands in front of the left forehead. Look forward.

45 a 第四十五式 馬步雲刀

Cloud the Broadsword in Horse Riding Stance

45a-1

45a-2

■ 右手持刀上舉，刀刃向外，左手掌托在刀面下面，兩手在頭頂上做雲刀式（圖45a-1；45a-2；45a-3）。

第四十五式 馬步雲刀

45
a

Cloud the Broadsword in Horse Riding Stance

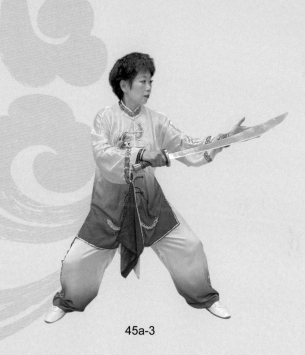

45a-3

Raise the Broadsword above forehead with the blade of broadsword facing outward, the left palm supports the face of the Broadsword, then cloud it above the head in horse riding stance.

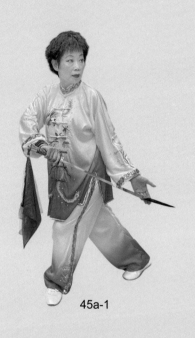

45 b 第四十五式 轉身沖天炮

Turn around and Uplift the Broadsword

45a-1

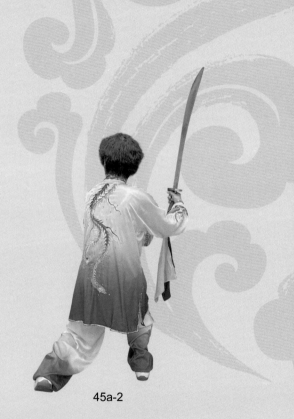

45a-2

■ 接雲手，身體右轉，右手持刀從左上向右下方拉劃弧，左掌按在刀背上，兩腳右轉下蹲隨即站立，右手持刀從右耳旁直立上舉，刀尖向上，左腳在前，右腳在后（圖45b-1；45b-2；45b-3）。

第四十五式 轉身沖天炮
Turn around and Uplift the Broadsword

The body turns rightward, the hand holding the Broadsword draw an arc from left to the right, with the left palm presses on the back of the Broadsword, relax the hip and bend both knees, squat and stand up slowly and lift up the Broadsword with the point of it facing the sky, and the blade of the broadsword facing forward, the left foot takes a step in front of the right foot in Empty Stance.

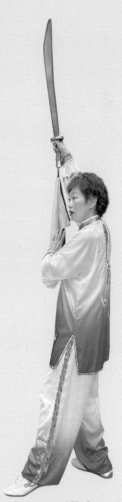

45b-3

46

第四十六式 左右掄劈
Hack Left and Right with Broadsword

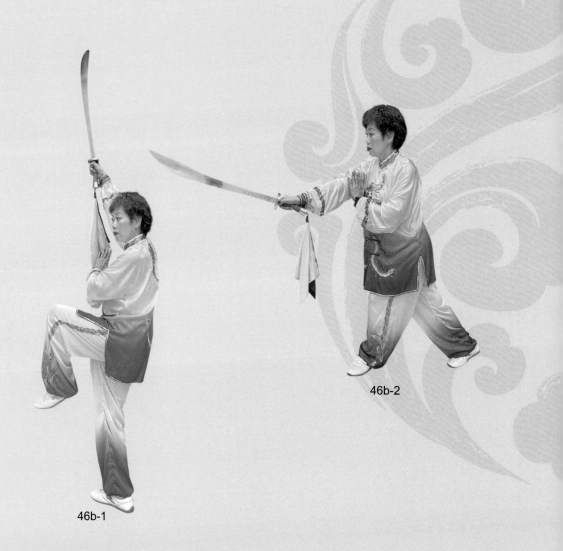

46b-1

46b-2

■ 左腳上提，向前落腳，右手持刀向左掄劈，再上右腳，右手持
刀向右反撩（圖 46b-1；46b-2；46b-3）。

第四十六式 左右掄劈

Hack Left and Right with Broadsword

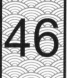

46

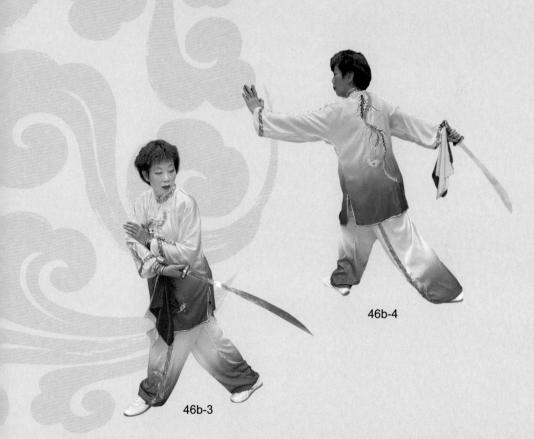

46b-4

46b-3

Raise the left knee and take a big step forward with the left foot first and hack left side, then the right foot strides forward and hack the right side, the left standing palm stands in front of the right chest during hacking. Look left and right as the waist moves its direction.

47 第四十七式 歇步按刀

Press Broadsword in Crossed Legged Sitting Stance

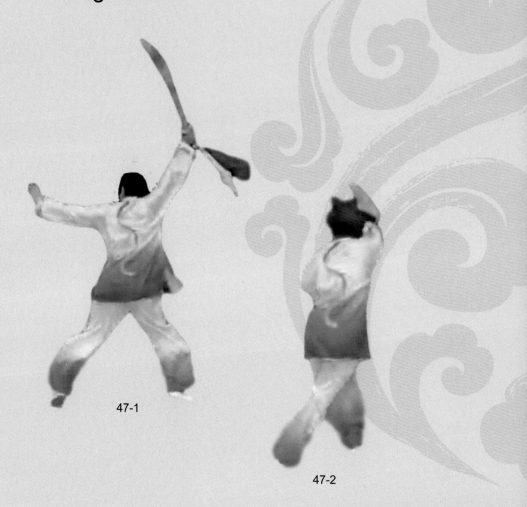

47-1

47-2

■ 接左右掄劈，左腳向前起跳，右腳落在左腳後方，兩腿交叉下蹲成歇步，右手持刀下按到左胯前，左掌放在右腕上，眼看刀尖方向（圖47-1；47-2；47-3）。

第四十七式 歇步按刀

Press Broadsword in Crossed Legged Sitting Stance

47

47-3

It starts from hacking left and right with arm swing, the left foot jumps forward in a big stride with both hands open to both sides, then squat down slowly, at the same time, draw a big circle and close two hands with the broadsword on the side of the left knee, the left palm center presses on the back of the Broadsword in Cross Legged Sitting Stance. Look leftward with standing head and relaxed neck.

48 a

第四十八式 旋轉掃刀

Turn Around and Sweep Broadsword Horizontally

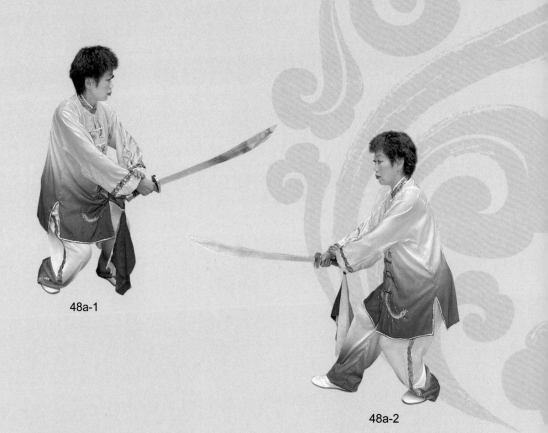

48a-1

48a-2

■ 接歇步按刀，身體向右轉 270 度，邊轉邊起（圖 48a-1；48a-2）。

Turn right and rotates 270 degrees, the body rotates with the hand holding the Broadsword and sweeps horizontally in circle.

第四十八式 退步撩刀

Retreat and Uppercut

48b

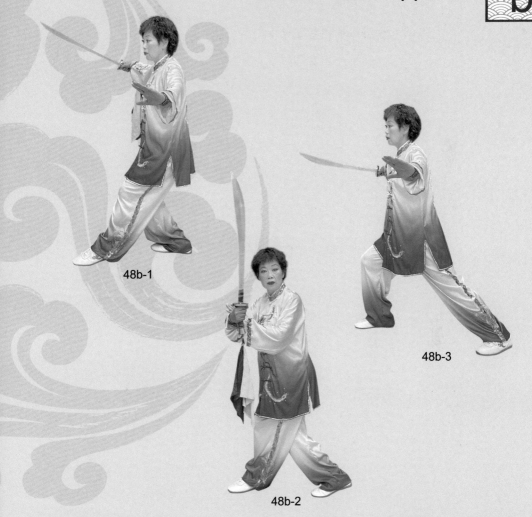

48b-1

48b-2

48b-3

■ 右手持刀向左右撩刀，左掌附於左臂前，注意撩刀動作比較大，腰的旋轉幅度也大，右手持刀要貼身，同時刀隨腰身轉動，頭也要隨持刀方向轉動（圖 48b-1；48b-2;48b-3;48b-4;48b-5）。

48b

第四十八式 退步撩刀
Retreat and Uppercut

48b-4

48b-5

The body rotates and raises up gradually, turn right and retreat the right foot first, then the left foot follows, at that time, swing the Broadsword and uppercut left and right with both hands open wide and close in front of the chest. Notice the movement of the broadsword should close to the body, and the body moves as the waist moves. Look at the direction of broadsword.

第四十九式 提膝劈刀
Raise left Knee and Stab

49

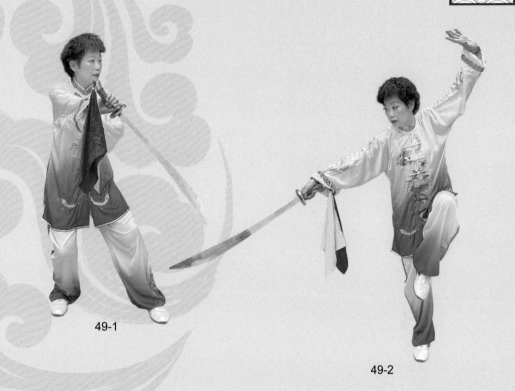

49-1

49-2

■ 身體微左轉，右手持刀上舉向右前掄劈，左腿屈曲上提，右腿獨立支撐，發力劈刀時身體微微向右前傾，刀尖斜向下，左掌心向左側撐，形成對拉勁，眼看劈刀方向（圖 49-1；49-2）。

Raise the left knee to waist level, swing the Broadsword from left to right and stab rightward, the body tilts to the right about 45 degrees, the point of Broadsword faces downward while the left palm pushes leftward with palm center face outward, it forms a pull and push force which helps balancing the body. Look at the stabbing direction.

50 第五十式 背刀里合
Carry Broadsword and Inside Kick

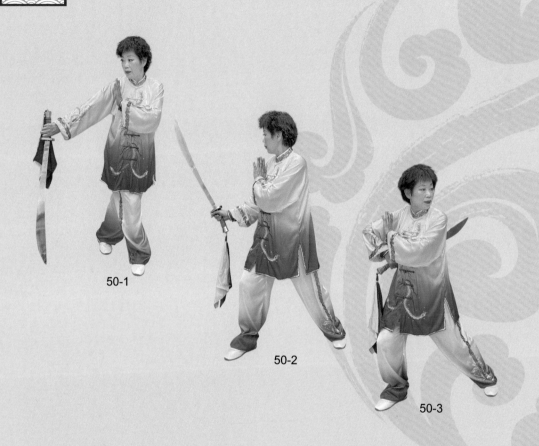

50-1

50-2

50-3

■ 左腳落步，右手持刀做腕花，身體向左轉，左腳外展，左掌平擺左側，與肩同高，刀背貼緊後背，右腳掌內扣左腳跟外展約 90 度，身體左轉同時右腿擺起做里合，左掌擊響右腳前掌時，左手仍然是背刀（圖 50-1； 50-2;50-3;50-4;50-5; 50-6）。

第五十式 背刀里合

Carry Broadsword and Inside Kick

50

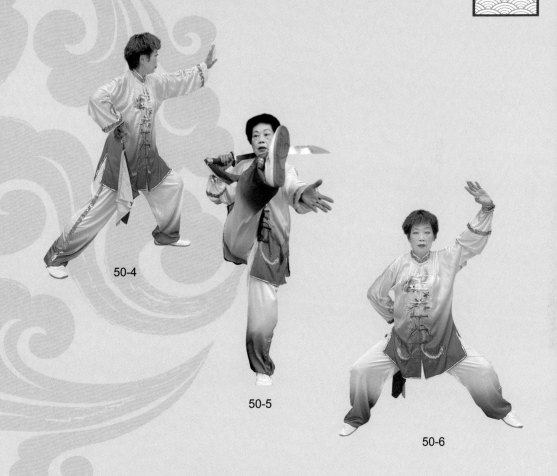

50-4

50-5

50-6

Drop the left foot and turn left, carry Broadsword on the back, swing the left heel outward and the right foot inward, then lift up the right leg and swing it inward, the left palm slaps the fore sole quickly when they meet in front of the body, Look forward.

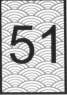

第五十一式 左叉步掄劈
Cross Left Foot and Hack Backward

51-1

■ 接背刀里合，身體繼續左轉，左腳向後撤一大步，隨即右手抽刀上舉向後劈，劈刀結束時保持臂和刀成直線左掌向左側撐，掌心向外，眼看持刀方向。注意劈刀結束時保持臂與刀成一直線，劈刀時力達刀的前刃（圖51-1）。

The body continues to move leftward with the right heel drops on the ground, then the left foot falls back, the hand holding the Broadsword swings upward and hacks downward, the left palm center faces outward, notice hacking action the arm should be in a straight line, and the force should exert at the point of the blade.

第五十二式 左弓步反撩

Uppercut Broadsword in Left Bow Stance

52

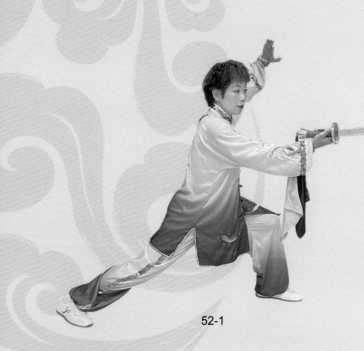

52-1

■ 接叉步掄劈，右腿向后撤步成左弓步，重心在左，與此同時，右手持刀翻腕刀刀向上，刀背向下，向前反撩，左掌側撑在太陽穴高度，眼看前方（圖 52-1）。

It starts from crossing left foot and hack Broadsword backward, the right foot falls back and become left bow stance, the center of body weight is on the left, at the same time, turn the right wrist and uppercut the Broadsword with force, put the left palm near the left forehead. Look forward.

53 第五十三式 架刀沖拳
Support Broadsword and Punch Forward

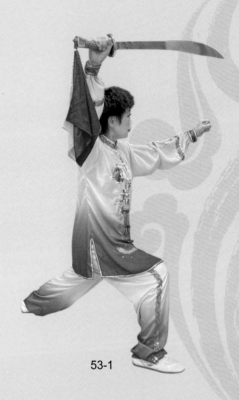

53-1

■ 隨著上步反撩，右腳上步，右手持刀做一個右腕花，把刀收回上舉架在頭上方，左掌變立拳從左向中心線沖出，架刀方向是東北（圖 53-1）。

After the uppercut, the right foot takes a step forward, the hand holding the Broadsword have a small Wanhua（腕花），that is to swing backward and forward in small circle), support Broadsword overhead with the right hand, while the left palm changes into fist and punch forward. Look forward directly.

第五十四式　上步接刀
Turn Round and take over Broadsword

54

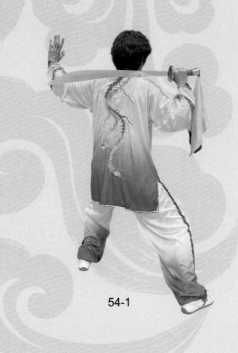

54-1

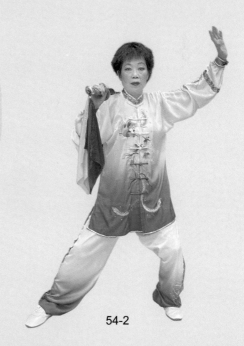

54-2

■ 隨架刀沖拳，左拳變掌和右手持刀合於頭上方再向左右分開，這時右腳內扣，左腳掌外展，右手持刀向左後纏頭，身體轉動時右手持刀架在右肩上，刀刃向外，同時右腳隨身體左轉繞行270度，和左腳平行，左手掌向左側撐，這時腰向左轉，右手持刀從右向左劃平圓，交刀時右手腕翻手，刀刃向外時，左手虎口向上接刀，右手下垂，左手持刀上提，身體微右轉，同時左腳上步成左虛步，右掌心向外撐，眼看正前方（圖54-1；54-2；54-3）。

54 第五十四式 上步接刀
Turn Round and take over Broadsword

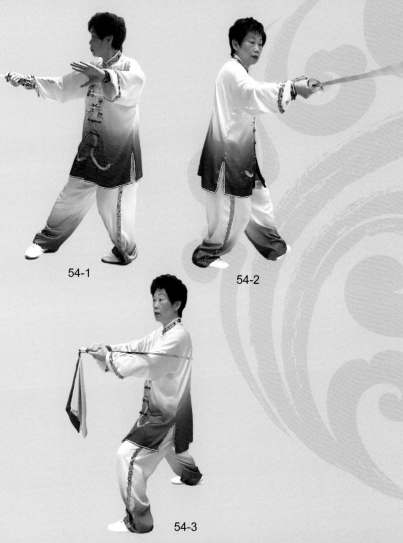

54-1

54-2

54-3

Change the left fist into palm, turn the wrists and move both hands with the broadsword rightward in shoulder level, with the blade of the broadsword facing outward, the left tiptoe swings outward and the right tiptoe swings inward, after turning about 270 degrees in 3 steps the left hand takes over the Broadsword.

第五十五式 轉身外擺腿
Embrace Broadsword and Kick Outside

55

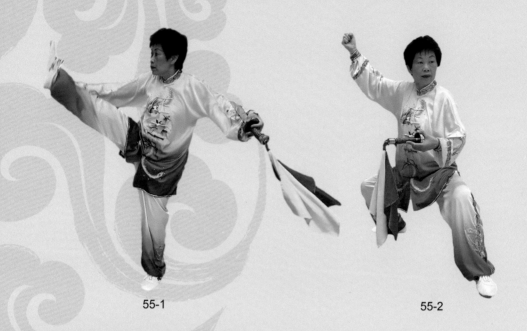

55-1 55-2

■ 接架刀衝拳，雙手向後劃弧，帶刀平捋，向左轉身走三步完成一小圓圈，（左腳掌外翻，右腳掌內扣），右手交刀左手，迅速提右膝做外擺腿，右腳向后落下成左弓步，右手握拳上舉，掌心向內，成打虎勢，虛靈頂頸，眼看左前方。（圖 55-1；55-2）。

It starts from taking over the Broadsword, turn right and swing the right leg from left to right in an arc, the right palm slaps the fore sole, the right foot drops and takes a step backward in left bow stance, the right hand lift up behind the right ear with fist center facing leftward, notice both arms should exert force and ward off. It is important to erect the head and relax the neck which makes one looks more spiritual. Look leftward.

56

第五十六式 收式還原
Closing Form

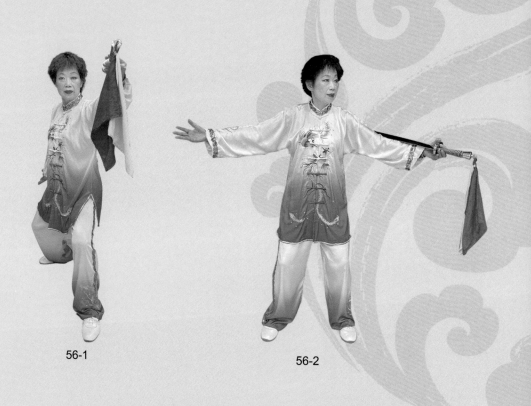

56-1 56-2

■ 重心後移，右腳上步和左腳并步，兩手從左右兩側緩緩上舉，合於胸前，同時兩手下降到丹田時，向左右分開下垂，這時兩腳并立成預備勢，虛靈頂勁，立身中正，面帶微笑，眼看前方（圖56-1；56-2；56-3；56-4）。

第五十六式 收式還原
Closing Form

56

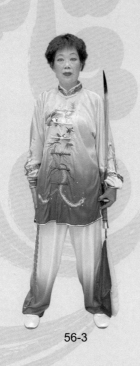

56-3

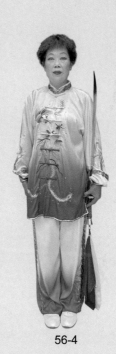

56-4

Move the body weight forward, the right foot takes a step forward in empty stance, the right fist punch forward from the waist, it is put under the left wrist, then withdraw the right foot and stand parallel to the left foot, both hands open and uplift slowly from both sides in circle, and then press slowly to the pubic region of which we call it Dantian (丹 田). Withdraw the left foot, both feet should be together and parallel. Look forward spiritually with smiling face.

侯力壯師傅收徒儀式　　　　　　　　　作者李嬋玲

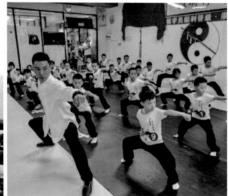

崇武道武術家園教學總監侯力壯師傅　　　　侯力壯總監和梁淑卿教練

深圳坂田崇武道武術家園學生

崇武道・武術家園

崇武道（深圳）文化有限公司創辦於 2017 年，位於深圳市龍崗區阪田雲族創客中心，是一家集武術培訓、賽事，表演，交流訪問等一體的現代化綜合武術教育培訓機構。武館場地寬闊、教學設施齊全，教學管理嚴謹，形成了獨具特色的教學體系。在崇武道武術家園發展壯大的幾年裏已成為武術圈的一顆閃耀明星，2019 年受邀參加深圳孔子文化節十周年慶典。

崇武道本著培養跨世紀的武術人才為目標，以弘揚武道精神、振興民族氣節為己任，從傳統武術中汲取、在現實運用中提煉為教學理念，並結合科學體育運動來研發，對當代學子有練習價值的武術教學體系，實現健康的體魄、自立自強的人格魅力。崇武道武術家園面向 4 歲以上少兒和成年人，常年開設課程武術、太極，散打、搏擊、女子防身術，養生功夫等科目，開展館內訓練、上門教學、學校合作等多樣辦學和服務形式。崇武道投入了大量時間來研發每一個武術動作，根據不同年齡段的生理和心理特點，分別制定教學內容和教學方法，科學貼合學員特點和需求；並細化教學過程，通過階段性考核晉級實時檢測教學成果。對於優秀學員，武術家園還提供參加國際武術賽事機會。經過多年累積，其授課方法與教學理念得到了學生、家長及社會群體的壹致好評。

崇武道教學十二方針：勇敢，勵誌，弘毅，敬畏，正途，傳承。崇武道致力於培養勇敢勵誌，寬宏堅毅少年，教導學員心懷感恩，敬畏生命，修正身走正道全力培養武學人才，弘揚中華武術，傳承民族文化。崇武道辦學宗旨：是以德會友、以武育人、以功夫為載體，讓更多炎黃子孫了解中國武術、學習中國文化，使更多家庭及孩子受益。

崇武道註重身心雙修的武術人才培養，教的不只是武術，更註重修養，武館並把這一理念深化到每一位教練身上。教練始終牢記武道精神的終極目標，堅韌不拔的尚武精神，學藝精益求精的追求意識。在多年的教學實踐中，崇武道培養和造就了一支專業能力強，教育觀念新穎，師德高尚的武術師資隊伍，專職教師名，武術段位名。其中創始人兼總教練侯力壯先生榮獲中國少林段位七段、中國武術段位第六段；是國家武術協會壹級裁判員，國家武術協會一級教練員，陳氏太極第十一代傳承人；曾多次在國際武士賽事上獲得多枚金牌，並代表國家出訪美國、新西蘭、新加坡、荷蘭等國家和地區交流和教學中國武術。

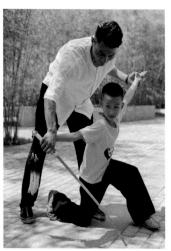

郭東衛、侯力壯教練　　　　　　　　　崇武道弟子

深圳崇武道武術家園　　　　　　　　　崇武道学生

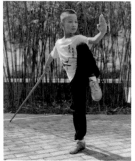

王德慶老師和侯力壯教練　　　　　　　崇武道弟子

祝賀禪武太極刀新書出版

陳世武簡介

陳世武：河南省溫縣陳家溝陳氏第十七世陳發科曾孫、陳氏第十八世陳照奎嫡孫、陳氏第十九世陳瑜獨子，陳氏第二十世嫡宗傳人。現居北京。

3歲開始跟隨父親陳瑜習練家傳拳術，他天資聰慧，悟性較高。9歲時，為了讓他搏眾家所長，父母將他送進北京武術院學習。11歲時，作為賽場最小的選手，首次參加了北京市太極拳比賽，套路工整大方，拳架沈穩，彰顯出良好的心理素質，從14歲起經常在各個公開場合進行表演，得到滿堂喝彩，獲得前輩的贊許。16歲開始協助父親領拳，自18歲獨立授拳至今，學生遍布中外。現任陳瑜太極 - 家傳陳氏太極拳功夫架推廣中心的主教練。其教拳層次分明，講解詳細清楚，示範認真到位，風趣幽默，課堂上善於與學員互動，方法靈活，氣氛活躍，眾多世界各地太極拳愛好者慕名前來求學。

上課地點：北京市豐臺區嘉業大廈一期B座1503室【地鐵5號線劉家窰站，公交劉家窰橋東站】

電話：13241704154 思雨

祝賀禪武太極刀新書出版

郭東衛師傅

　　香港紅館太極康樂會顧問，8 歲開始於家鄉山東武術學校習國家規定拳，15 歲後往武當山武術學校深造內家拳，從小習武，熟練武術基本功包括身法、拳法、腿法、騰躍、空翻等，習武當功夫十多年，並習八卦、形意、八極等內家拳及養生保健功夫，精於北方內外家拳種，曾獲多個武術比賽冠軍，曾隨功夫團出訪多國，現於香港和中國內地教授武術。

祝賀禪武太極刀新書出版

汪猛師傅簡介

香港紅館太極康樂會顧問

深圳崇武道武術家園教練

汪師傅是最早在香港傳授北少林功夫的師傅，自幼習練少林功夫，34代俗家弟子，持教十數載，後以「專才」而入香江，教授弟子萬餘，擅長拳、棍、刀等。除練武外，喜好哲學，望籍武藝見人生，以達外練功而內修心。

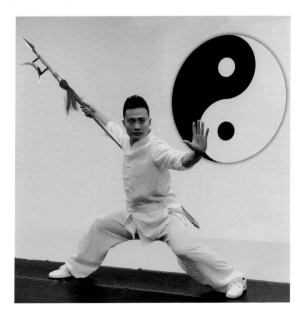

武館地址

德輔道西 36 號帝權大廈 9 樓

國際武術大講堂系列教學之一
《禪武太極刀》

香港先鋒國際集團 審定

香港國際武術總會有限公司 出版

香港聯合書刊物流有限公司 發行

代理商：台灣白象文化事業有限公司

書號：ISBN 978-988-74212-9-0

香港地址：香港九龍彌敦道 525 -543 號寶寧大廈 C 座 412 室

電話：00852-95889723 \91267932

深圳地址：深圳市羅湖區紅嶺中路 2018 號建設集團大廈 B 座 20A

電話：0755-25950376\13352912626

台灣地址：401 台中市東區和平街 228 巷 44 號

電話：04-22208589

印刷：香港嘉越發展有限公司

印次：2021 年 1 月第一次印刷

印數：1000 冊

總 編 輯：冷先锋

編 輯：李嬋玲

編 委：董繩周 侯力壯 梁淑卿

責任印制：冷修寧

版面設計：明栩成

圖片攝影：Joe Kam 何偉雄

網站：https:// www.taijixf.com https://taijiyanghk.com

Email: lengxianfeng@yahoo.com.hk